MW00811871

TROPE

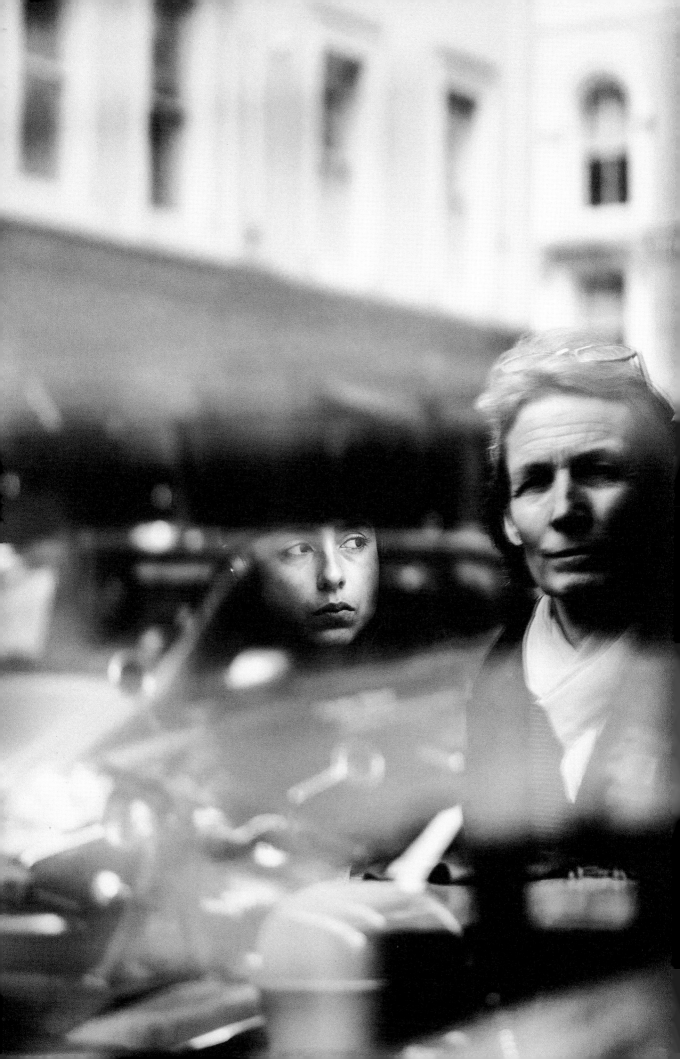

TROPE

LUCY HAMIDZADEH
Unfinished Stories

TROPE EDITION

VOLUME I

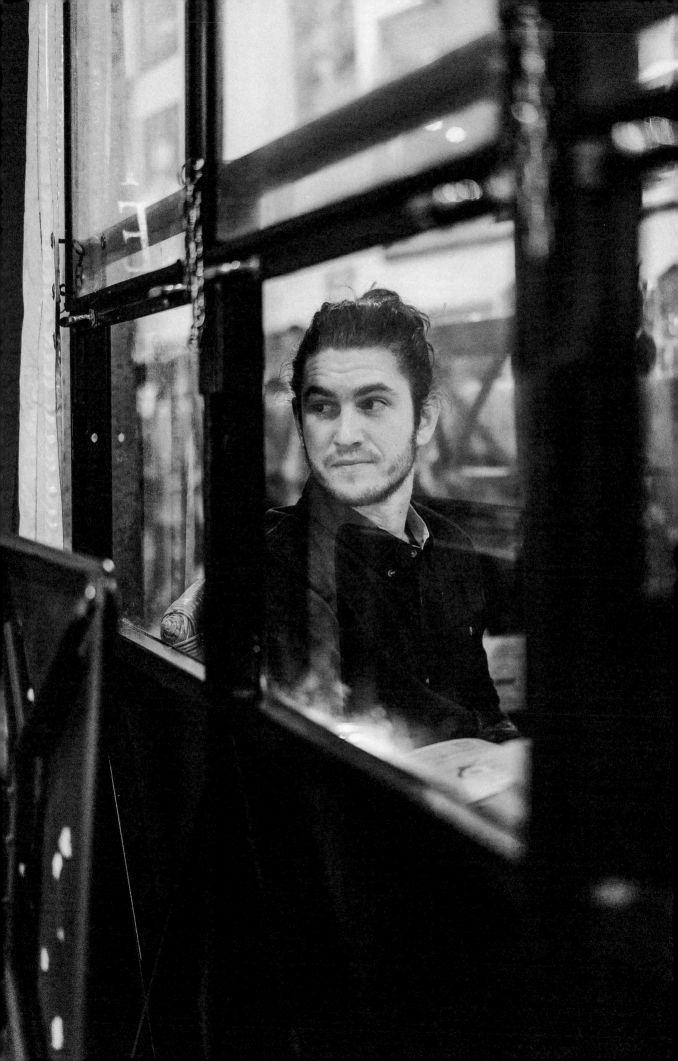

INTRODUCTION

Trope Publishing is proud to present the work of London photographer Lucy Hamidzadeh in this debut volume of the Trope Editions Emerging Photographers Series. *Unfinished Stories* presents the daily lives of everyday people: on the streets, in trains and at cafés, often lost in their own thoughts, but captured in an indelible way by Lucy's discerning eye and camera. Their 'unfinished stories' are the inspiration for her first solo book of words and pictures, making for a lasting glimpse of the fleeting moments she encounters.

Hailing from southeast London, Lucy is a photographer with a deep affection for unpredictable weather and the hustle and bustle of city life. Her distinctive approach to street photography creates images that are complex and multi-layered, yet feel effortless in their execution. Instead of following trending visual language, Lucy creates fictional micro-worlds that are emphatically her own. In addition to capturing the image, she is a masterful storyteller, transporting the reader into the intimacy of the moment. Her unique sensibilities have informed a body of work that is both vulnerable and accessible.

We created this new contemporary book series to introduce young and emerging artists from around the world to a wider audience. Enjoy Lucy's vision of the world around her.

Sam Landers
Editor

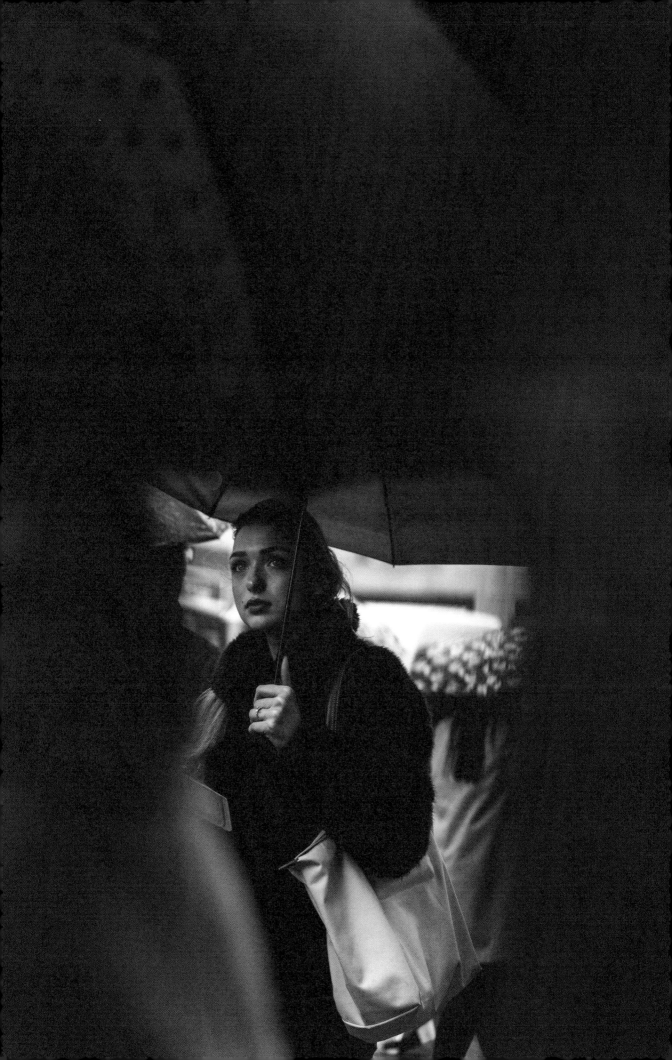

UNFINISHED STORIES

I never thought I'd have my name on the cover of a book that encased moments, feelings and thoughts, and say 'here it is', a book by me, Lucy, the photographer and writer. But life as I've discovered shocks and surprises you, and here I am in that tense 'I didn't know a thing, and now look'… a book!

These moments, frozen in time, are snippets of daily life that I've captured walking the streets – sometimes for an hour or two, but more often for hours and hours, and days and days. The beauty I find in these moments is that they are all unfinished, and they are all unique. I never know what it is that I'm going to capture until I see it. It's usually a flicker of something that catches my eye in such an overwhelming, powerful way, and that's when I press the shutter.

My take on street photography allows me to step out of my own life story. It allows me to escape reality and disappear into someone else's story, just for a moment – not just in my hometown of London, but all over the world. It's a place where I can choose to go alone and where no one really knows me. It's a satisfying solitude. When I walk down the street and I open my eyes, ears and nose to the sights, sounds and smell of a place, I feel like a small part of something bigger. Everything and everyone is new, and in that moment, I know I have the freedom to discover a whole new world.

And so, I guess, I took these 'moments' of mine and put them together with my thoughts, feelings and imagination just like they were a sport. I exercised every one of those unfinished stories, and unknowingly at the time, I found a 'sport' that I love. I know it's also one that I will always love and one that I've become addicted to. And, it's also a 'sport' that has allowed me to be me.

I don't take photos to please anyone but myself. The freedom of picking up my camera gives me a reason to go out and observe daily life, strangers and the world around me.

I want to capture something about the people I see, but at the same time I like to create my own version of who I think the person is – let's be honest, the reality rarely lives up to the romance, and I'm OK with that. But I do think we could all benefit from letting ourselves get lost in the romance of an idea or perception instead of having to know every single excruciating detail, and so that's why I called this book *Unfinished Stories.*

On the surface, these individuals and moments are very different, but somehow, they share a common bond – they all are unfinished stories that I've created. I don't know their stories, and I guess the romantic part of me is not interested in knowing all the facts. I think it's this emotional distance that has been at the core of my development as a photographer and artist.

In every melodramatic, romantic, ridiculous way, these unfinished stories of people that I've captured saved me from an intensity I was once afraid to share. So what I want from my work is, I want to inspire you. I want to make you feel something you might not have felt had you not flicked through these pages. I want to draw you in, I want to grab your attention, and I want to evoke a feeling. I think that's where my writing also plays an important part in my work. Combined with my photography, it's another way of sharing my imagination. It's a way of me putting my thoughts and feelings down and getting lost in the moment. Perhaps I'm talking to my younger and a much shyer self here, but allow yourself to get lost in your own curiosity and freedom. Enjoy just being you. If you want to write, write. If you want to travel and see the world, don't wait for someone else to make that decision for you.

By sharing these moments, I want you to use your imagination and put yourself in my shoes. I want you to feel what I felt when I pressed the shutter. It's my way of seeing the world, and perhaps seeing it a little differently. It allows me to also make sense of people, and myself, a little better too.

Lucy Hamidzadeh

Through the Looking Glass

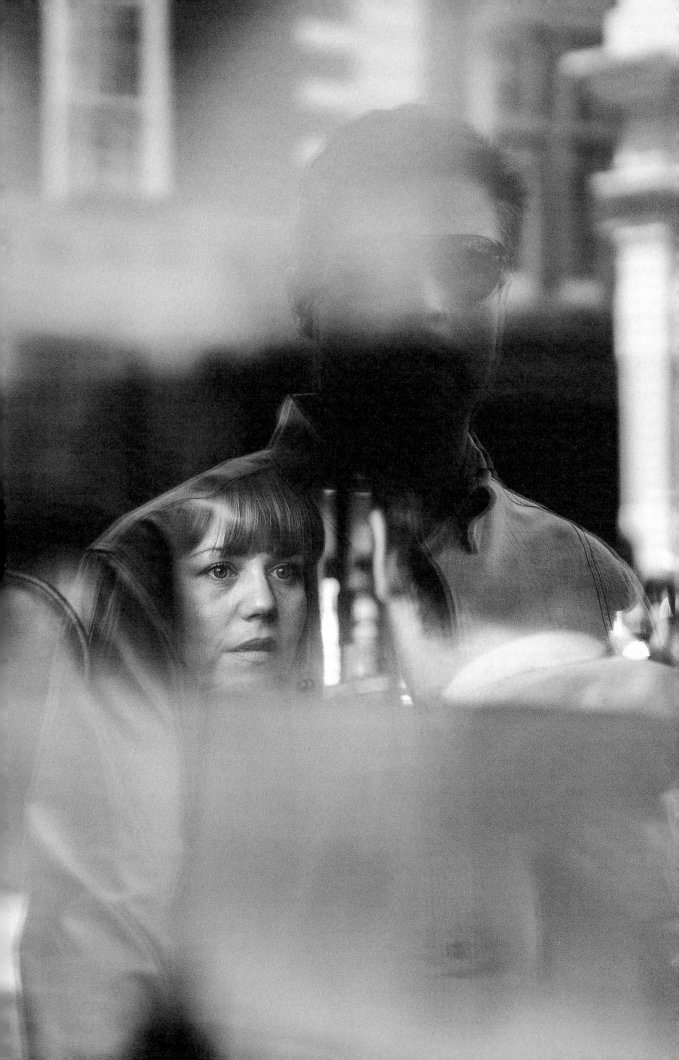

Coffee shops and cafés are perfect places to observe people. I am fascinated by peering into windows and looking to see what is occurring behind the glass.

It's not just the person sitting behind the glass that interests me, it's the reflection of what's being played outside the glass too. It's like a three-way story – me, and quite often two strangers. All of us living different stories, but for a split second, we're connected. The reflections create endless stories and a curiosity in me. It's where I feel I have the chance to really step into my subject's story.

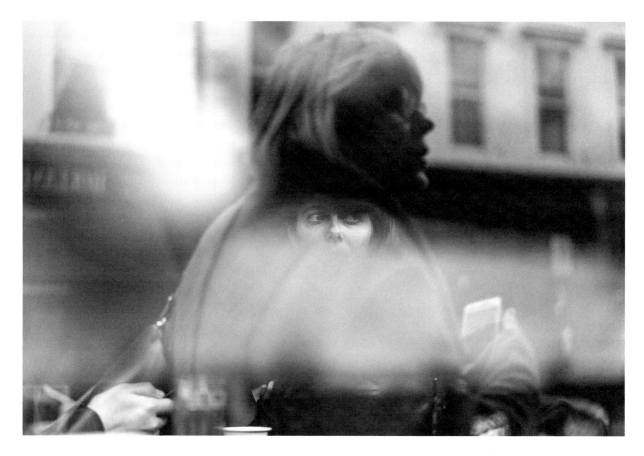

~ I never wanted to lose you. But I did; now I want to forget you. But I can't...

~ she looked up & met the eyes of the girl on the other side of the glass

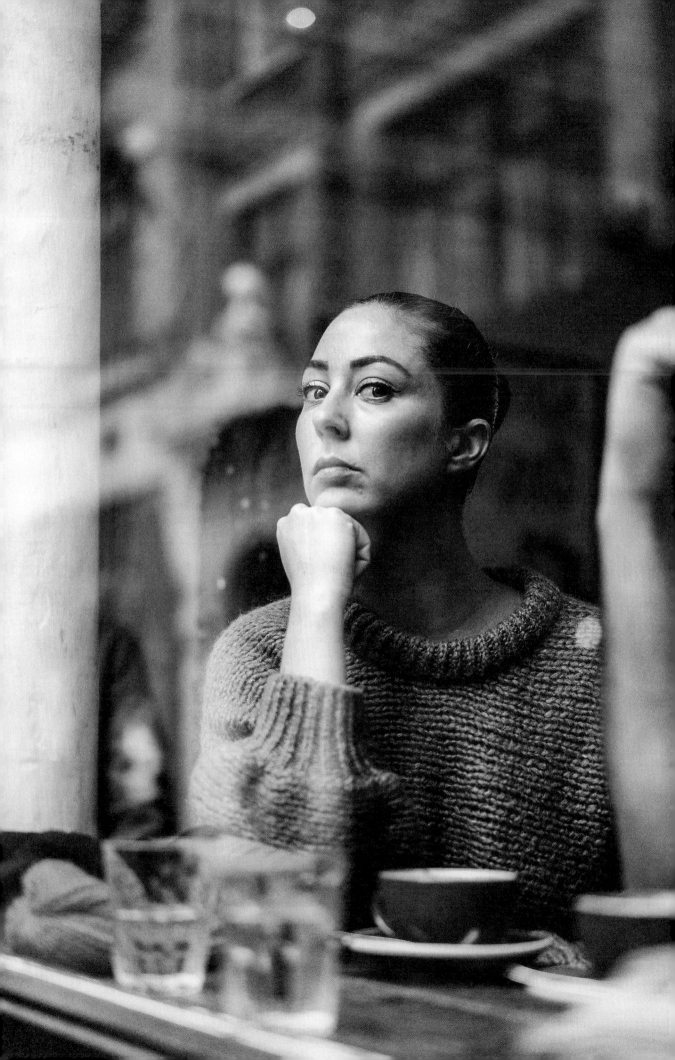

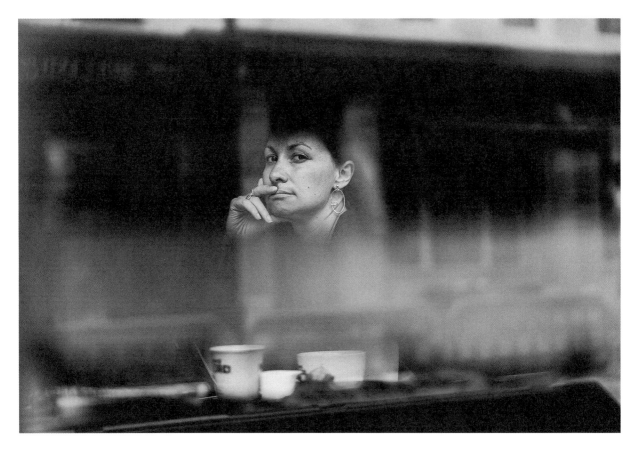

~ how do you feel?; do they ever ask?; you pass me by & I wonder am I ok?

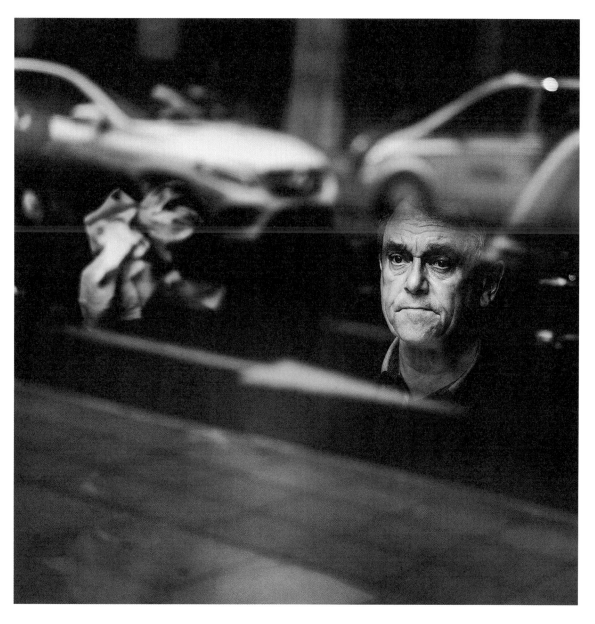

~ I'm not really sure I like the portrait of you that I'm seeing; because it's not the portrait that you once painted for me. In your lines, you were someone to love; so in my mind, you were also someone to love. However in reality, you were a completely different story when I got you figured out

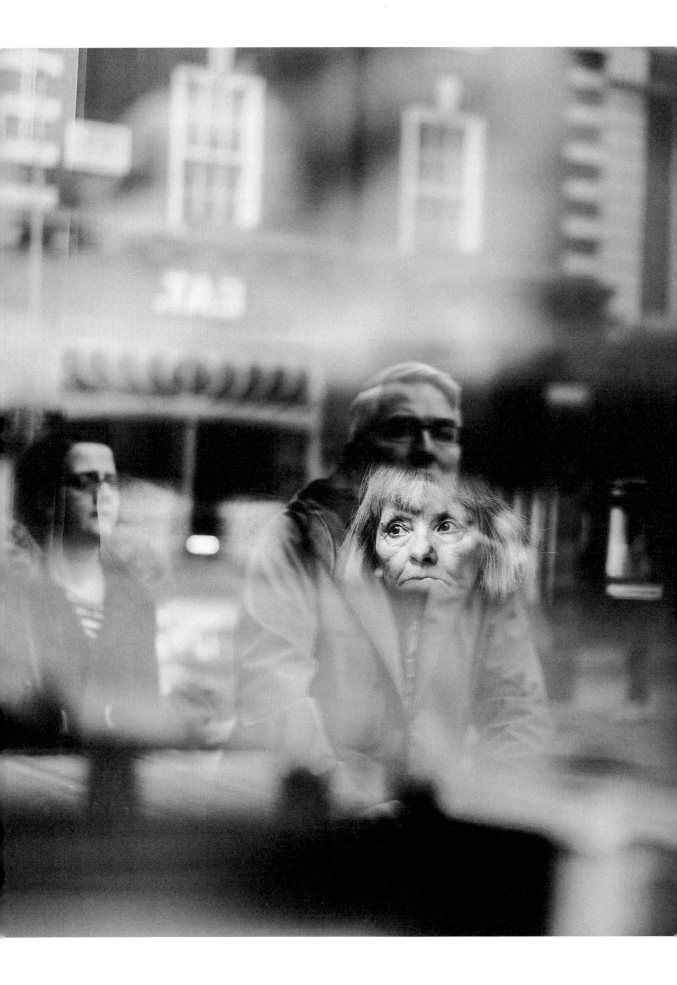

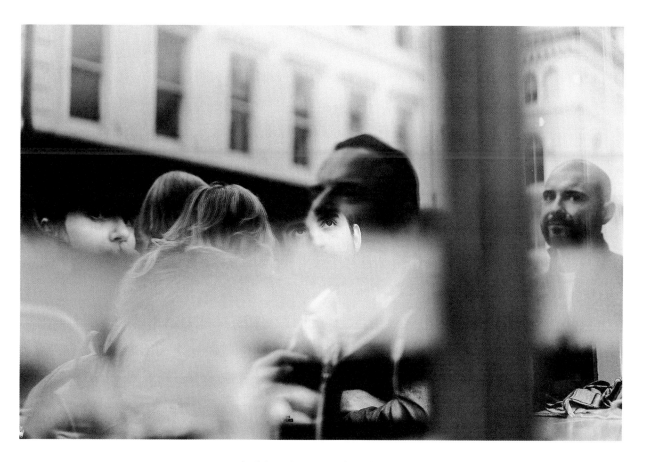

~ don't just choose me when it's convenient; choose me as much as I choose you.
Because, one of these days, you'll be too late

~ do you remember, when we watched the sunset?
You hugged me so tight like you would never let
me go; now it's all just a memory

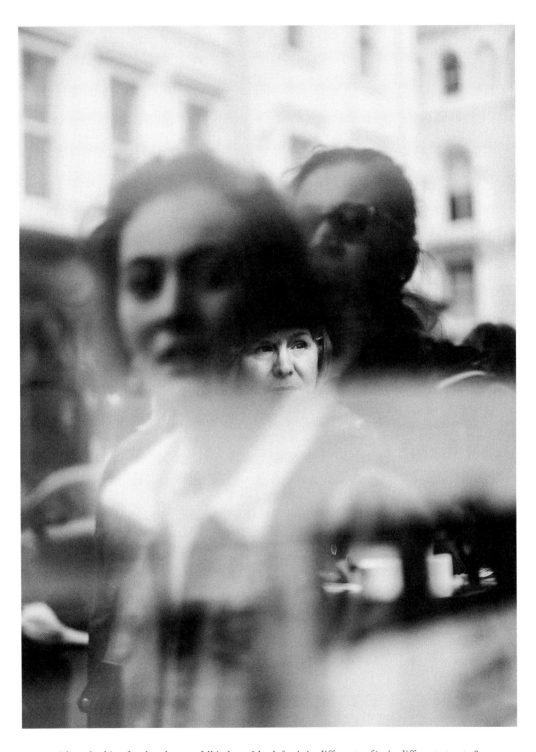

~ I keep looking for the place we fell in love. I look for it in different cafés, in different streets & at different times of the day, hoping that since we lost it, it'd be out there somewhere

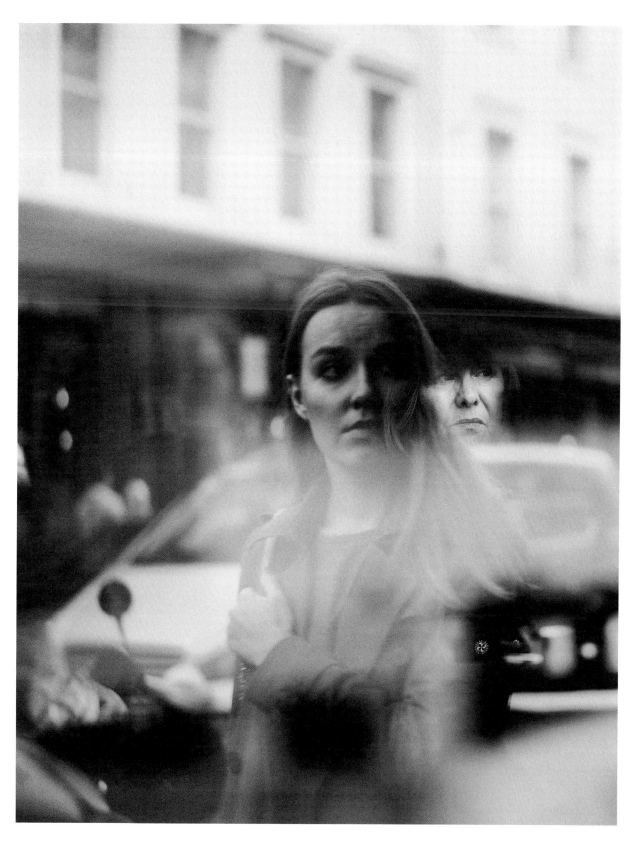

~ and that's when she realised… it's ok; 'I knew the risk of heartache & that's also part of my love too'

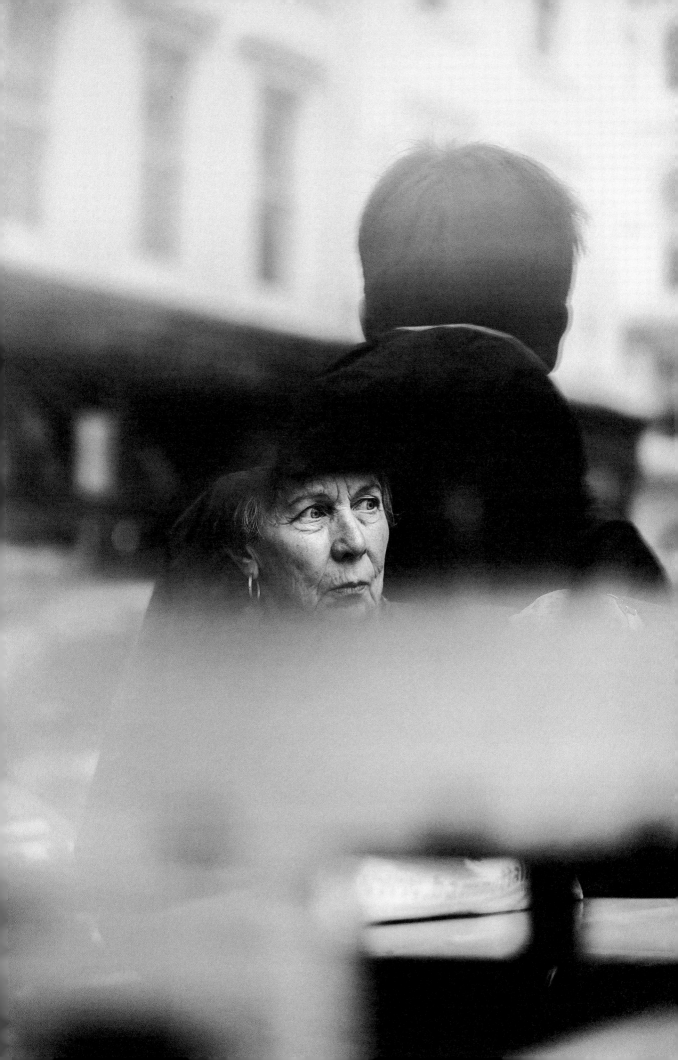

~ it's been months since I last felt your touch,
 but it feels like it was only yesterday. I remember
 the way you looked into my eyes. And the way
 you whispered 'goodbye'

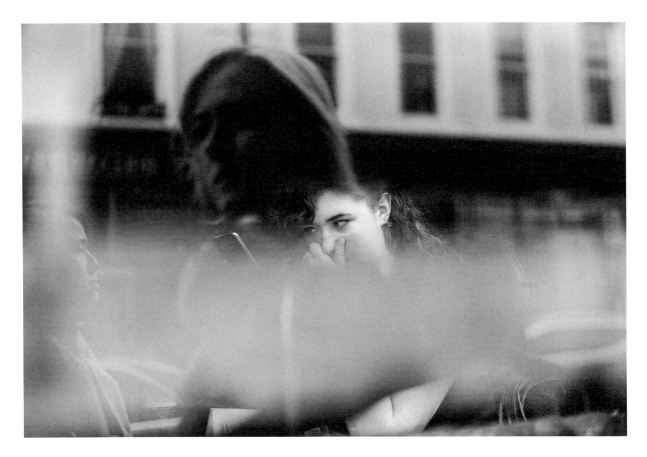

~ and so, I burned all of our photos; erased all of our messages. I only wish I could do the
 same with all of our memories... I wish it was that easy

~ to the guy who stole my heart; please give it back

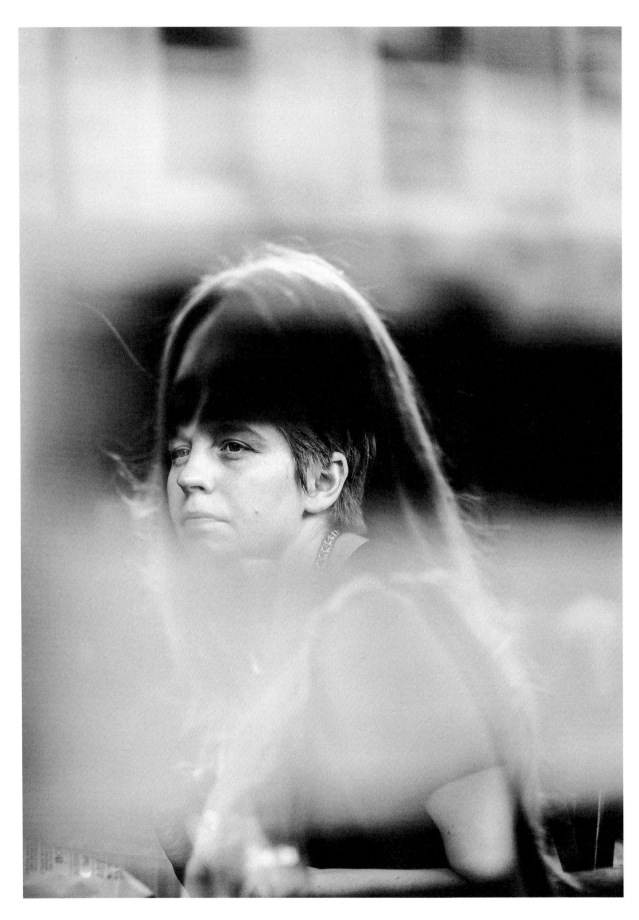

~ I'm afraid to have my heart broken by someone who didn't even know they had it in the first place

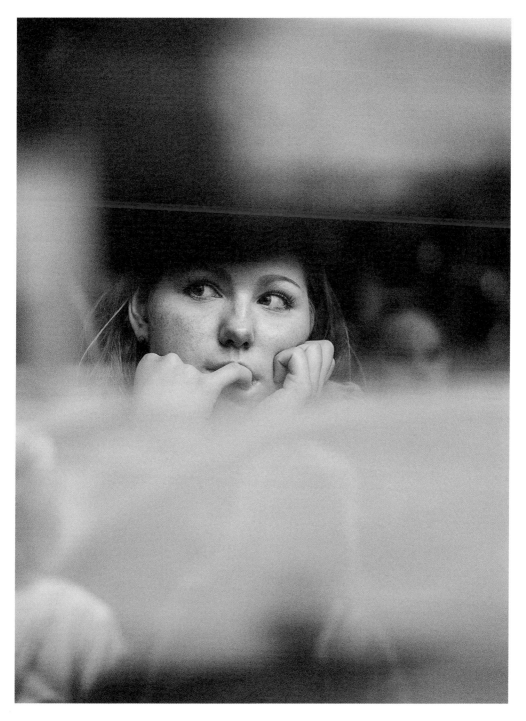

~ I will always remember that day we met as strangers; we fell into lovers. I wanted it to last forever

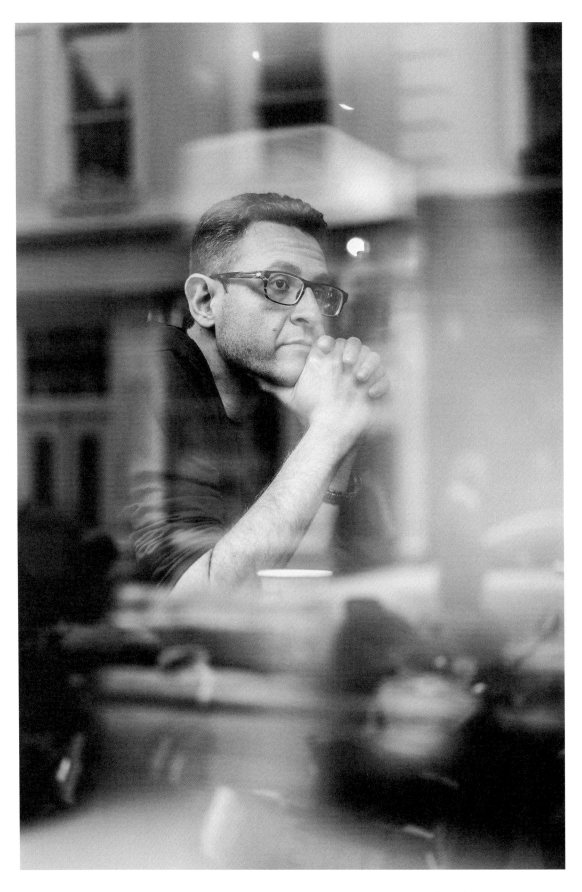

~ the lonely hour. When he closed his eyes, all he ever thought about was her. And, as he sat there alone,
staring deeply into the distance, he began to wonder 'are you thinking of me too?'

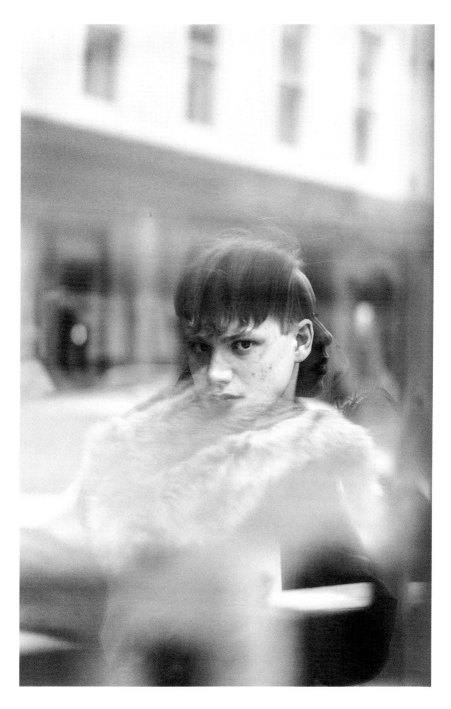

~ I thought I saw you yesterday, in the face of an anonymous stranger

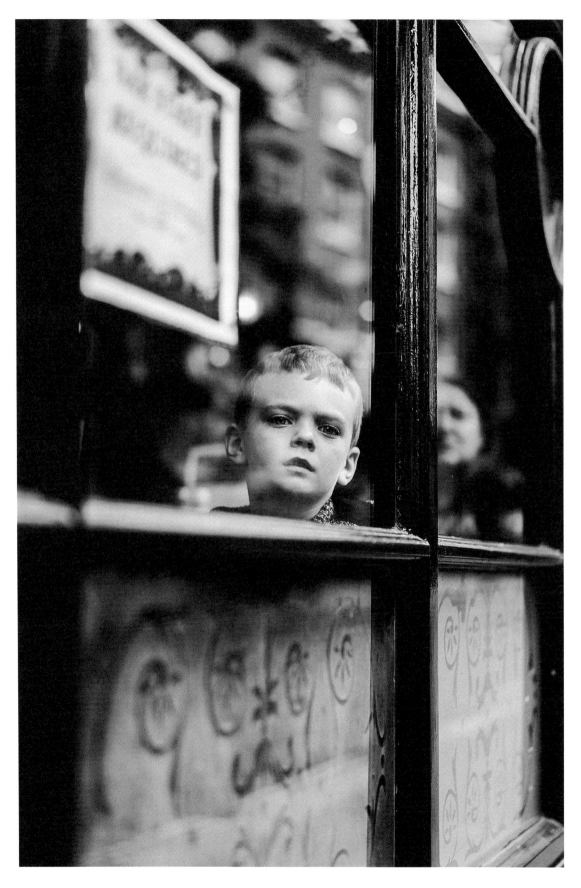

~ dear little boy; you don't know me, but I know there are entire worlds behind your eyes. And, whilst
you're searching for answers to questions that you can't quite ask, sooner or later you're going to find
you've 'a lifetime of stories' hiding deep inside

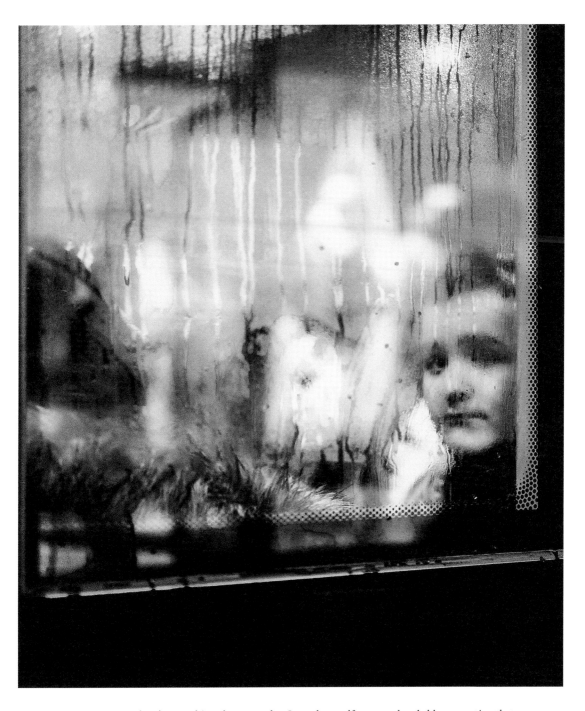

~ there's something about you that I attach myself to; an unbreakable connection that you
have complete control over

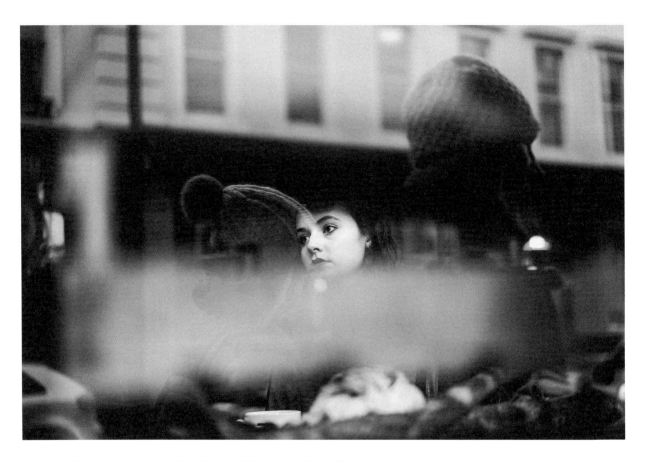

~ you're swimming in your thoughts. I could have stayed here a little longer to watch you.
 You look so perfect; sad & tired, but perfect

~ sometimes, it felt like a setup. The world he lived in and the world he stepped into

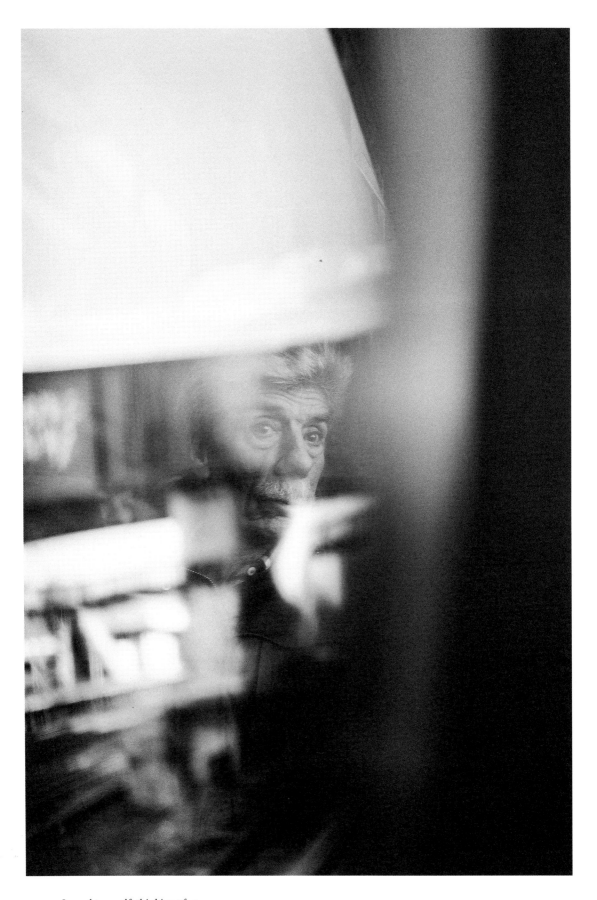

~ I caught myself, thinking of you...

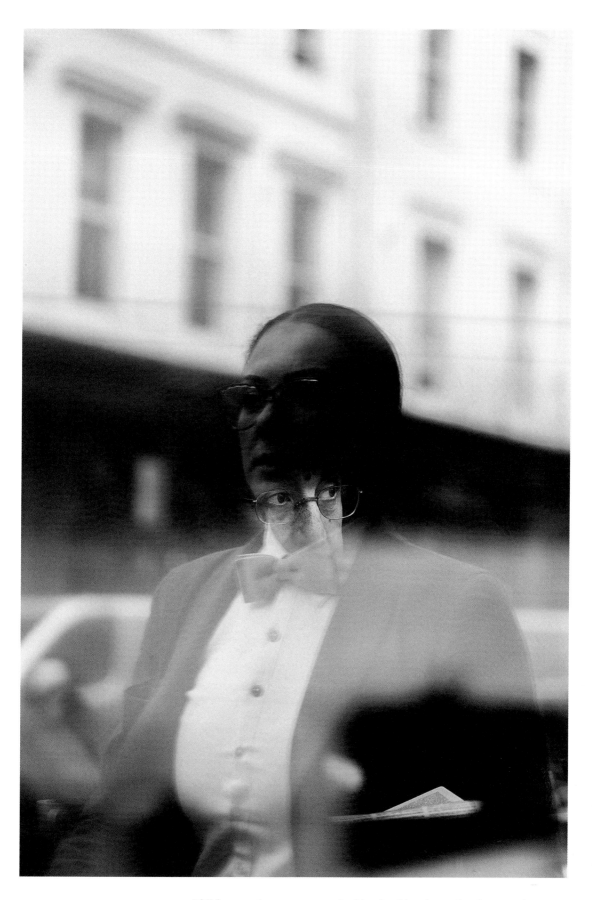

~ I fell for you when you were not looking; but I loved you when it was too late

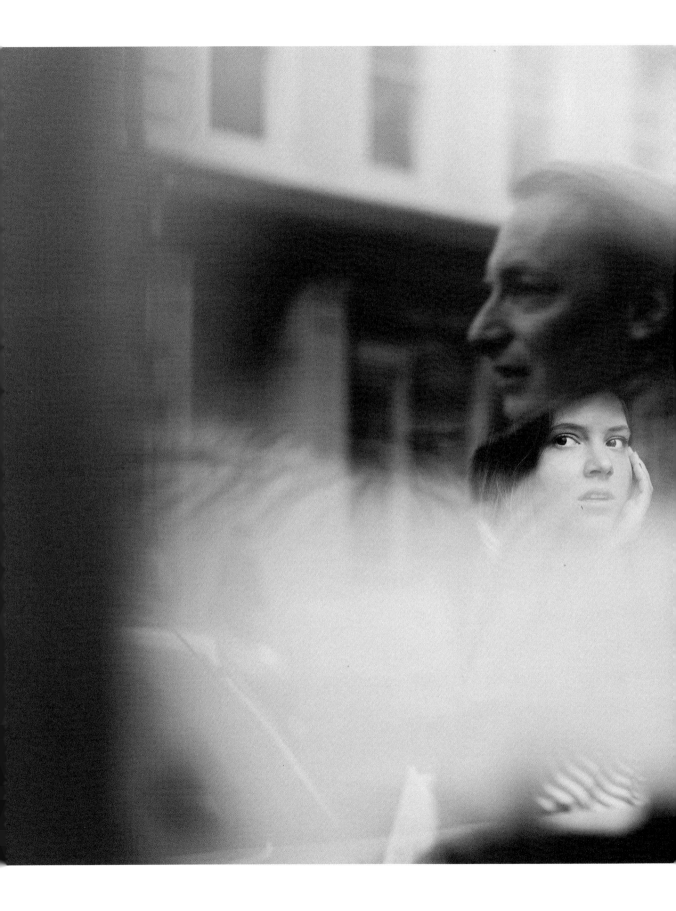

~ I love your voice, even when it told me goodbye

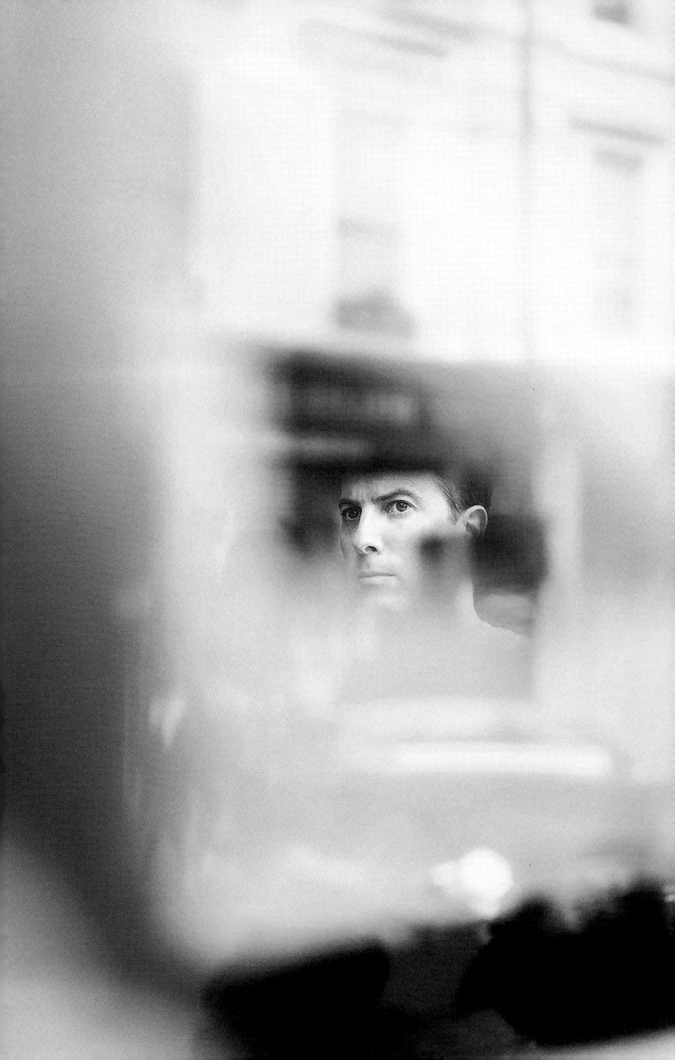

~ have you ever dreamed of a love you've never met?

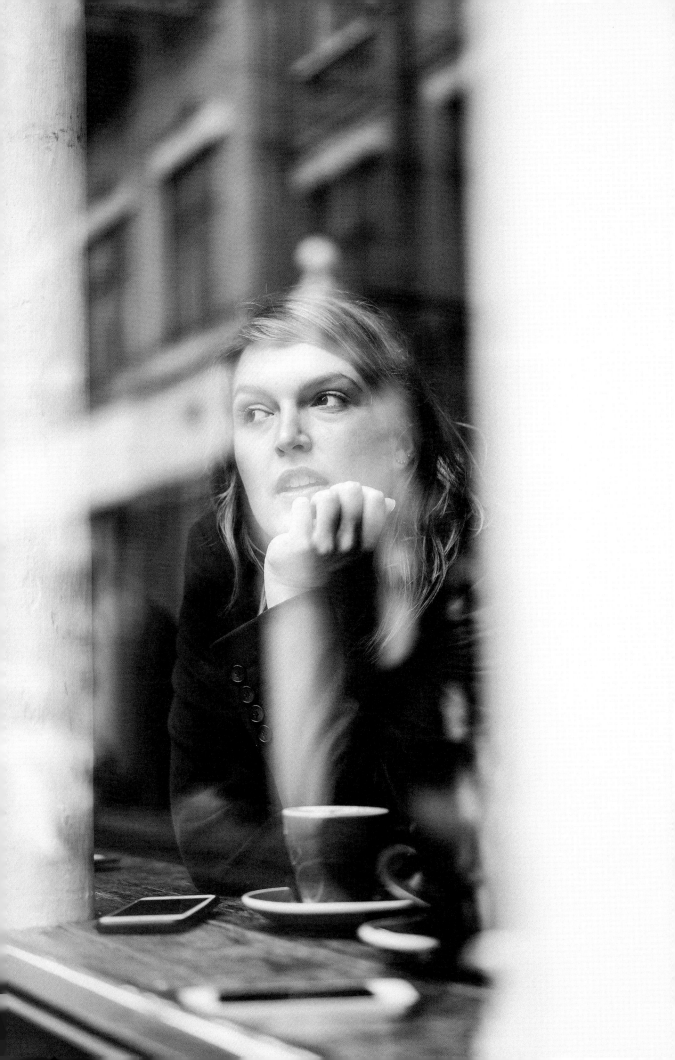

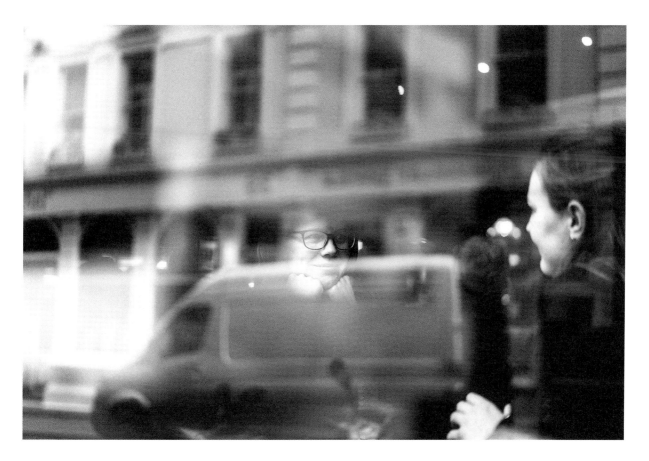

~ I didn't mean to, it was all a coincidence that I fell for you

~ your detailed text messages; his one-worded responses.
 You make yourself available even when you're not;
 but he rarely finds the time. And yet you hold on
 because your love is unconditional

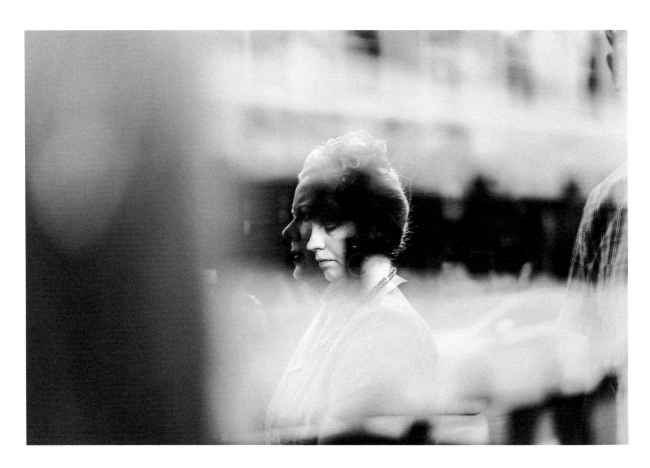

~ so you said you wouldn't ever leave; but where are you now? If this was all for attention;
 I applaud you, please step forward & take your bow

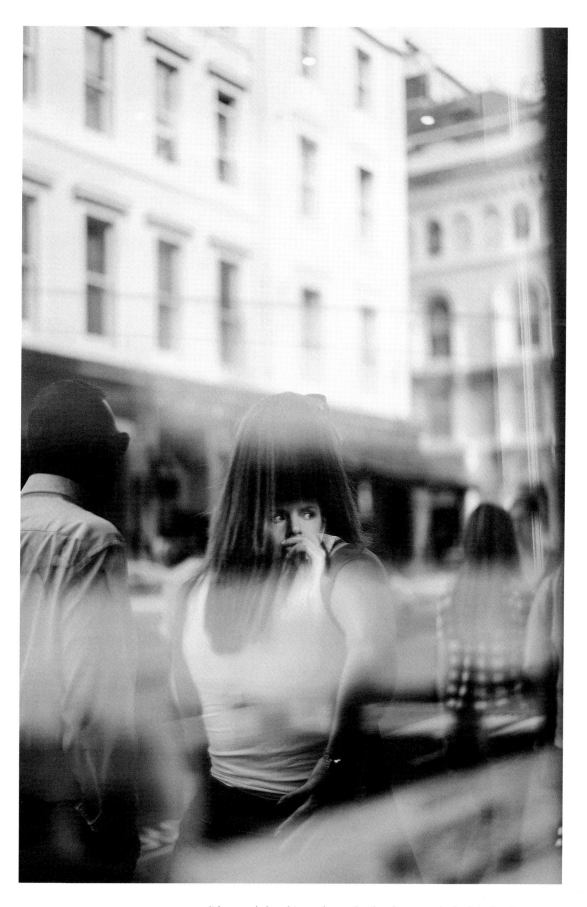

~ 'I love you', she whispered; an echo that does not echo back in the silence

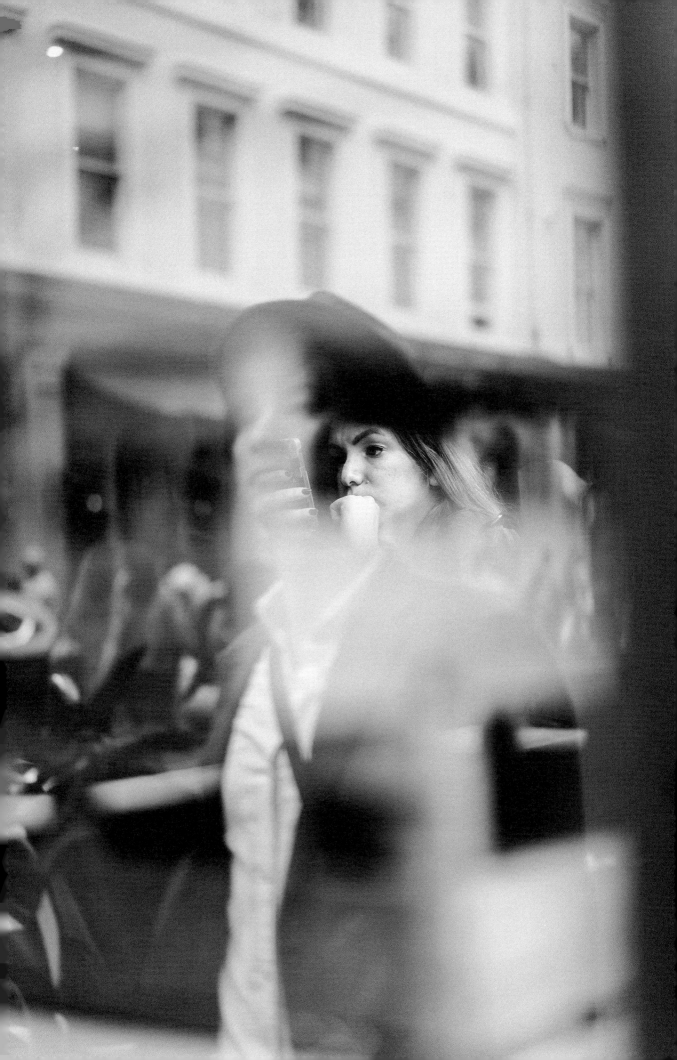

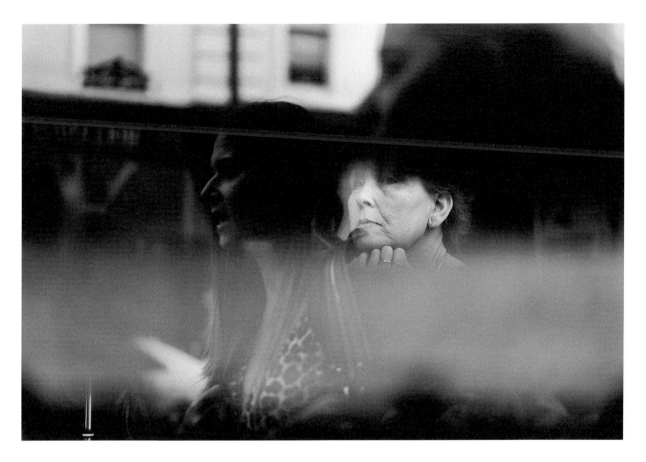

~ thinking about the last few days. I wonder what it all means? And is it all in my head?

~ understand, I know that feeling, of being lost.
I see your silence, but trust me, you are braver
than you think

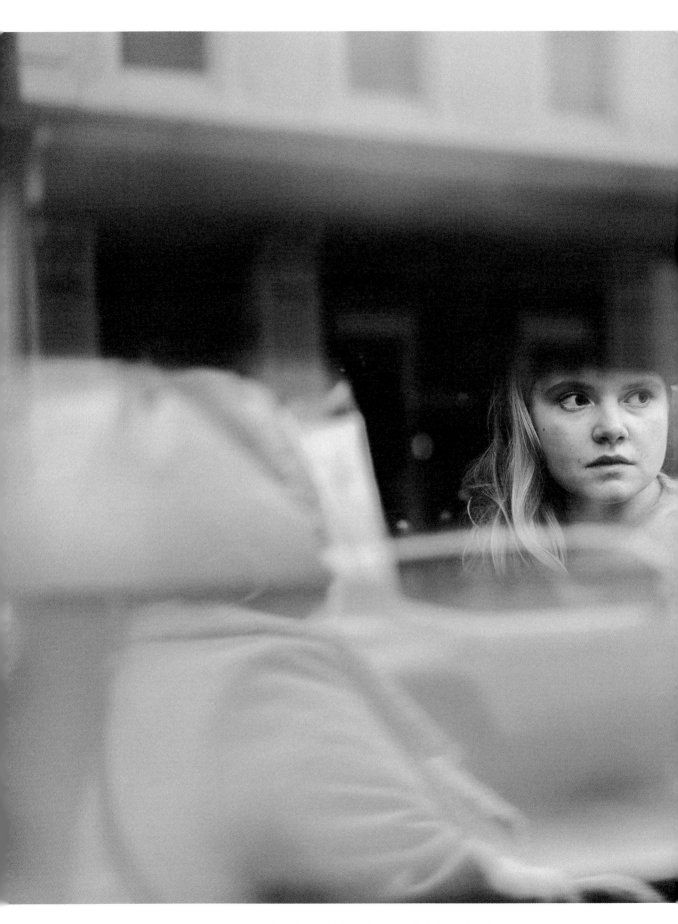

~ she sneaks glances every now & then, hoping he doesn't see – she's in love with him

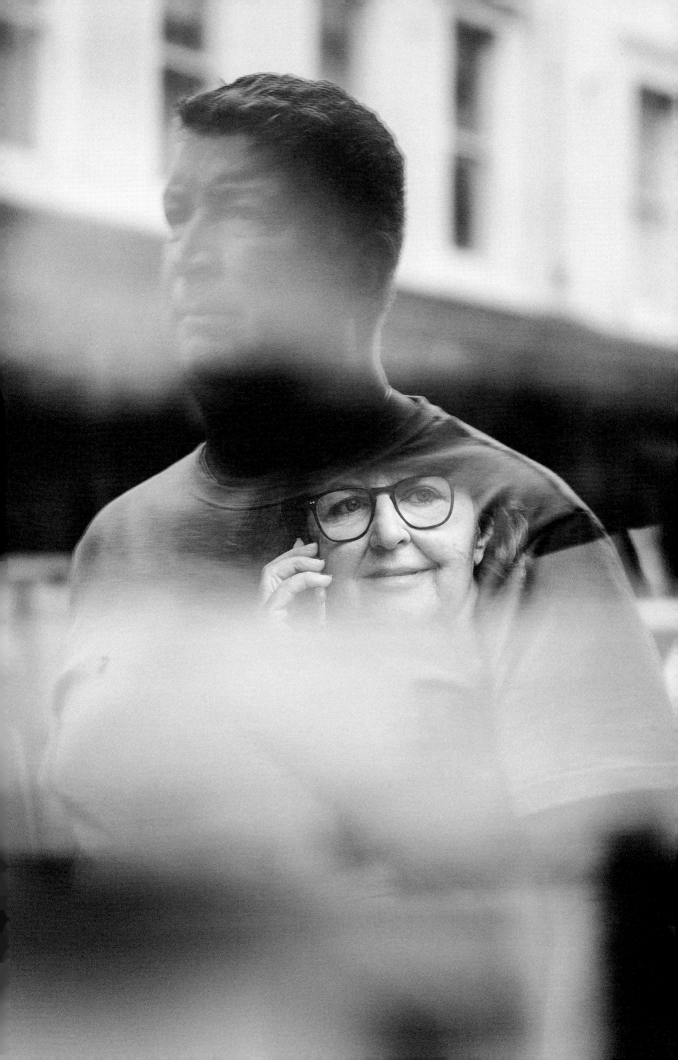

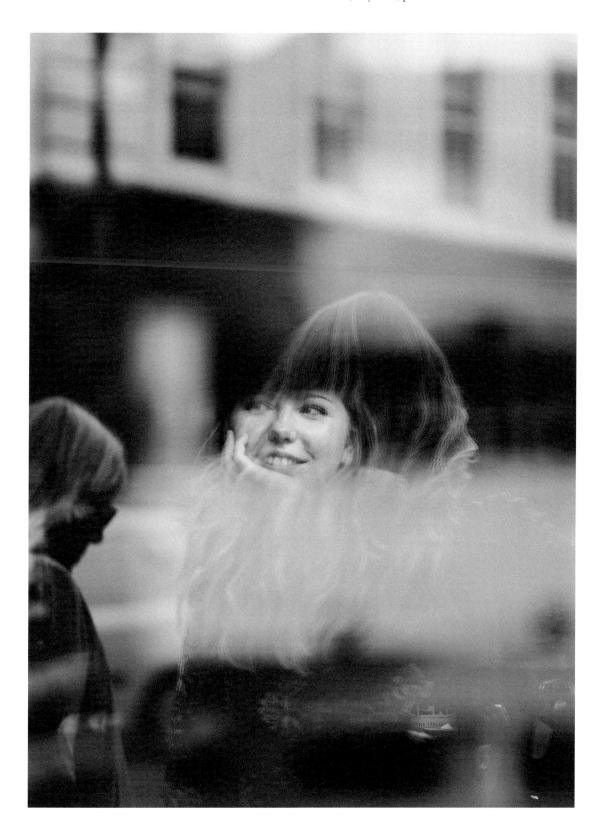

~ I know you're far from my reach, but I love you in the strangest way one could

~ if I love too intensely, forgive me.
It's a bit like a movie reel; you feel as
though it will last forever; until it ends

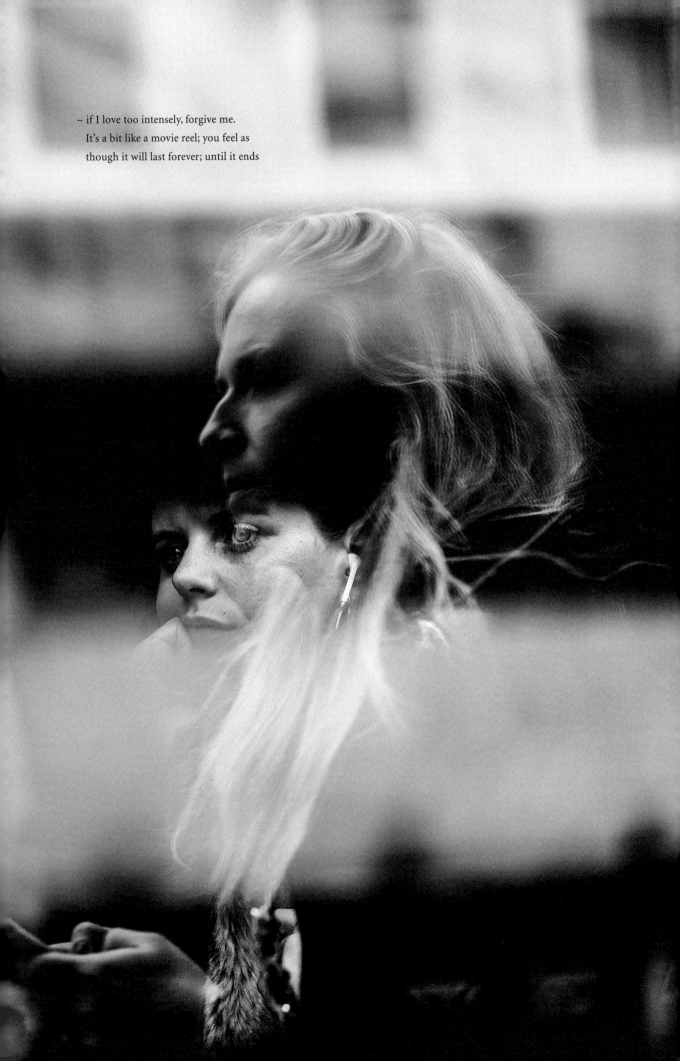

Intimate Strangers

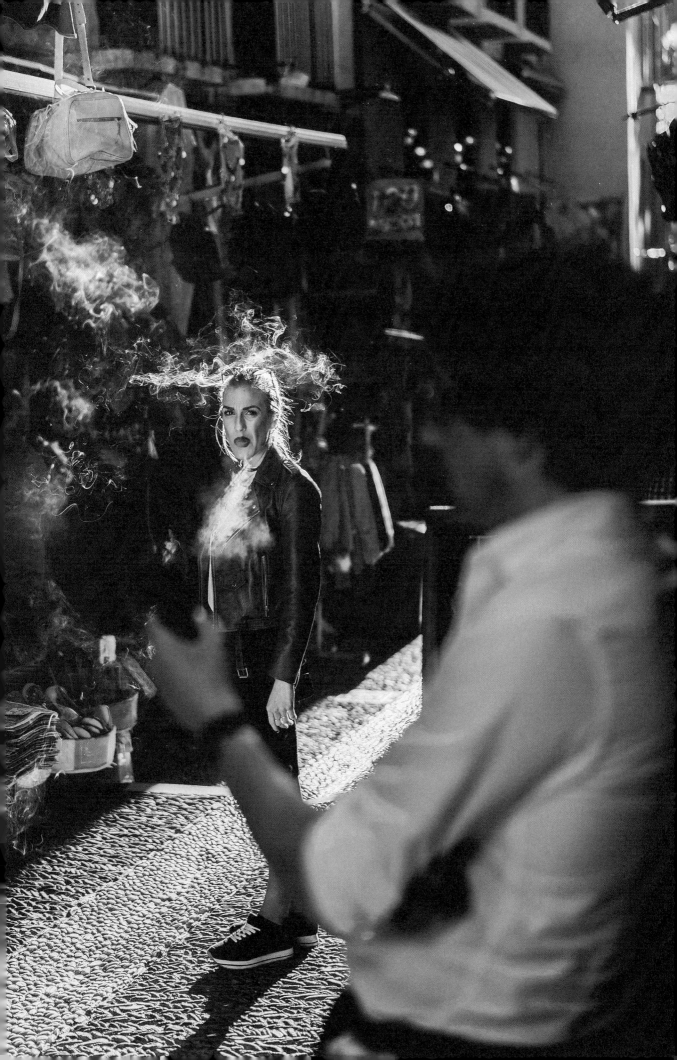

Just a random moment, a daily situation which quite often remains unseen. I want to feel close to the person in front of the camera, but in an intimate way.

Without actually knowing the people in front of the lens, I try to capture what they are experiencing. What emotions they are going through – happy, sad, excited, maybe they are falling in or out of love, typing their thoughts and feelings into a text message or catching up with friends, or maybe they are simply lost inside a book. I want to be able to share these daily moments of complete strangers before the moment is gone.

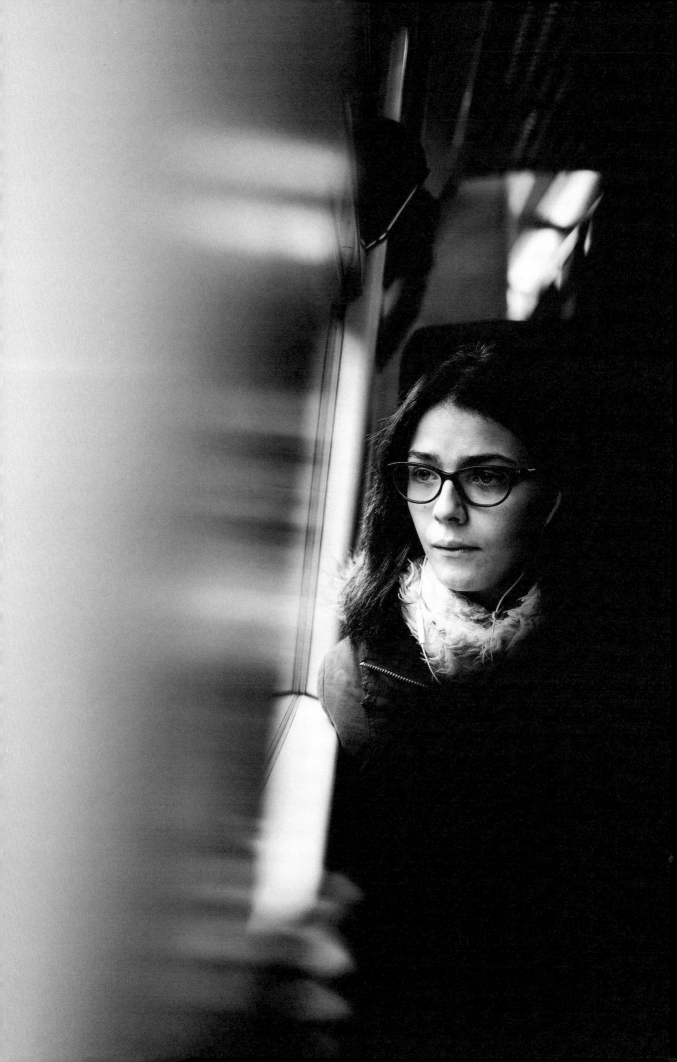

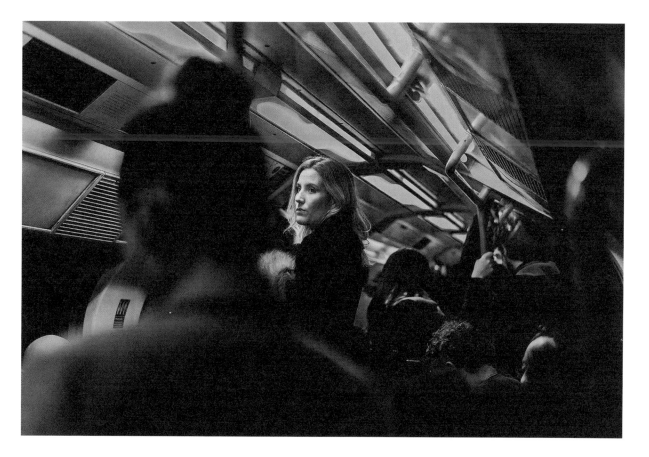

~ she had the tendency to let her mind wander, but to her that's what made the world interesting. One small thought led to another & one memory triggered another

~ the worst part about your goodbye is that you didn't even say it;
I just figured it out on my own

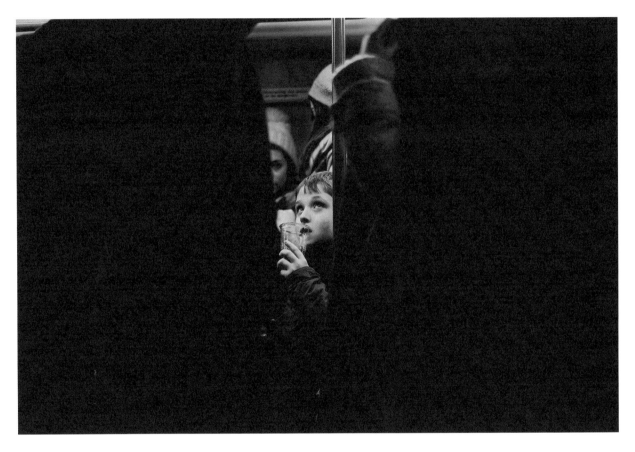

~ dear little boy; one day you're going to catch someone stealing glances at you & you're going to feel giddy with excitement; one day you're going to smile to yourself when you read a text from someone you meet; one day someone will explore each dimple on your face & read every sentence that you speak. And, one day you're going to fall in love & that someone is going to tell you how special you are whenever you need to hear it & even when you don't

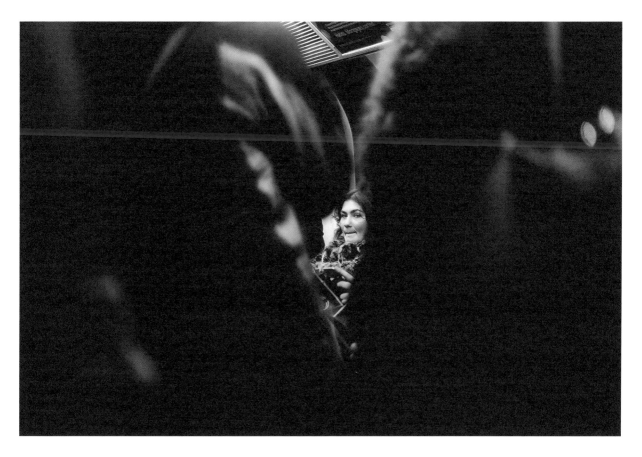

~ if I asked you to shut your eyes & to picture everybody you loved, how long would it take for you to recognise yourself?

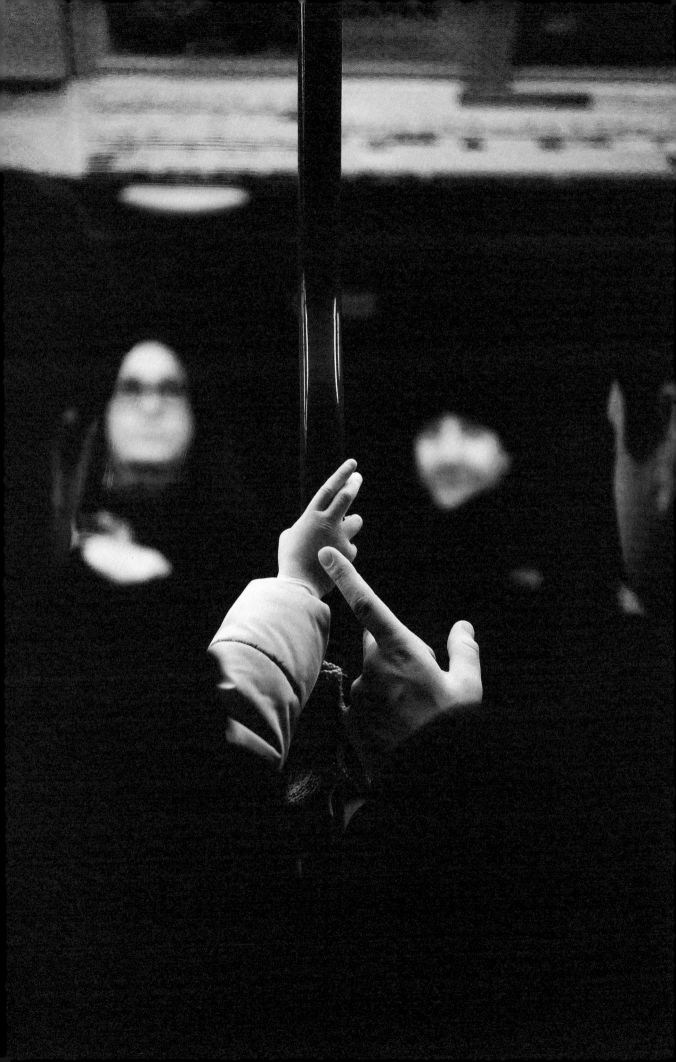

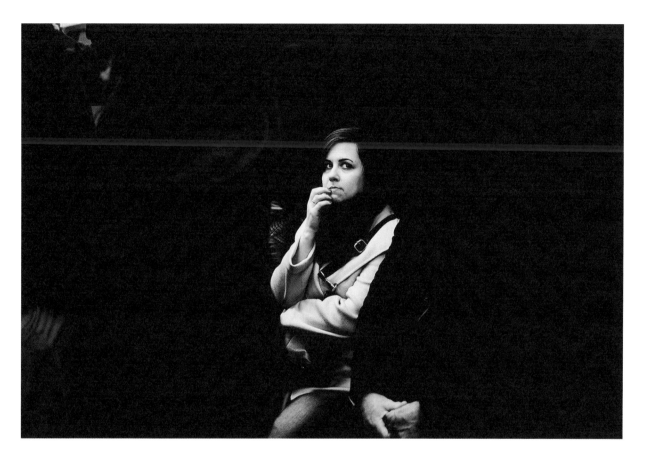

~ she's made up of broken promises & bittersweet heartaches; of a love she hoped would last forever
 & a friendship worth a thousand ships that sailed away

~ you know those moments & they needn't
 be very long or seem very important &
 you're not even searching for them? Well,
 they can be absolutely heartwarming

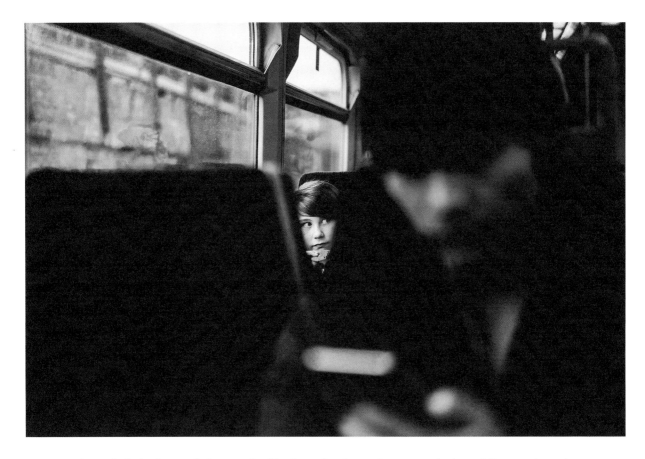

~ you know the look when you feel eyes on the side of your face, but you're not completely sure? You turn; instantly catching them looking. Their eyes stare & then they've gone looking somewhere else like the floor, or out the window, or pretending to be deep in thought

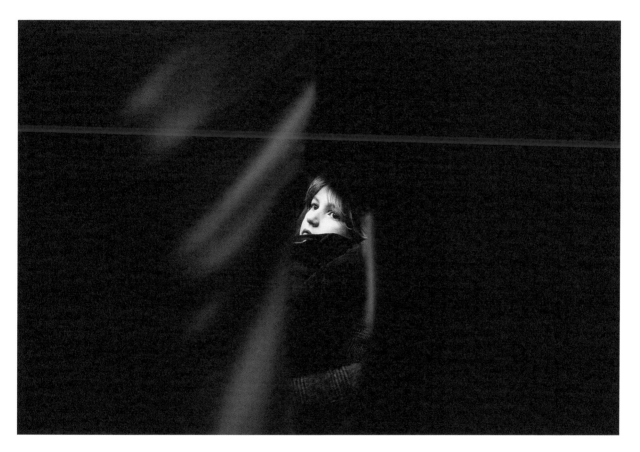

~ no one sees your strength, do they? No one sees the silent battle you fight against your overprotective mind that's trying to keep you safe from harm. You are strong. Don't let anyone convince you otherwise – especially not your thoughts

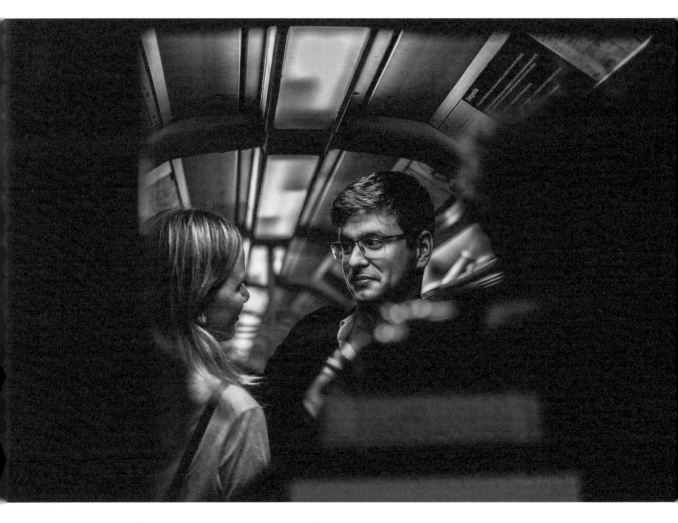

~ I saw you there, staring into her eyes, like she completes you

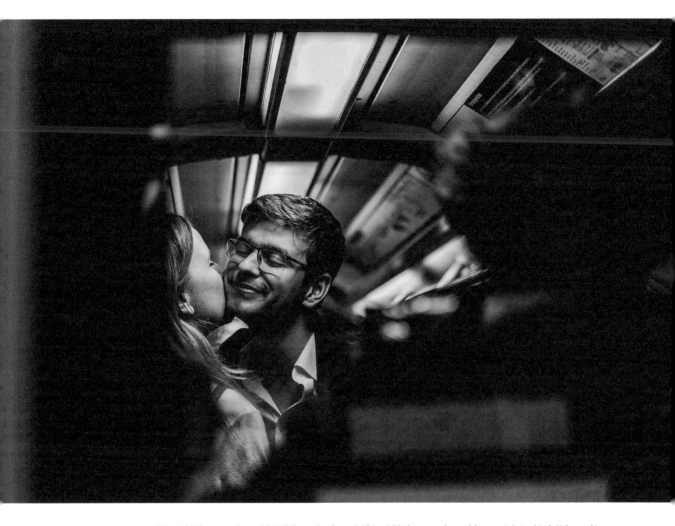

~ if I said 'I love you' would it fall on deaf ears? If I said 'I love you' would you sigh & think 'I know'?
If I said 'I love you' would you wish for me to stop saying it?

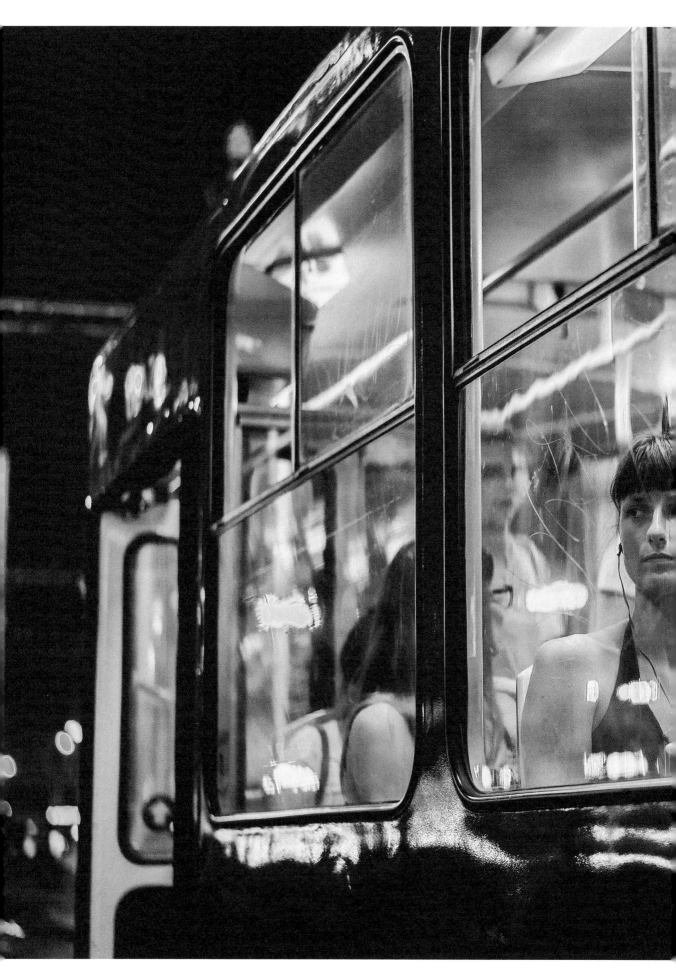

~ after all this time, I still reminisce about all the times we shared

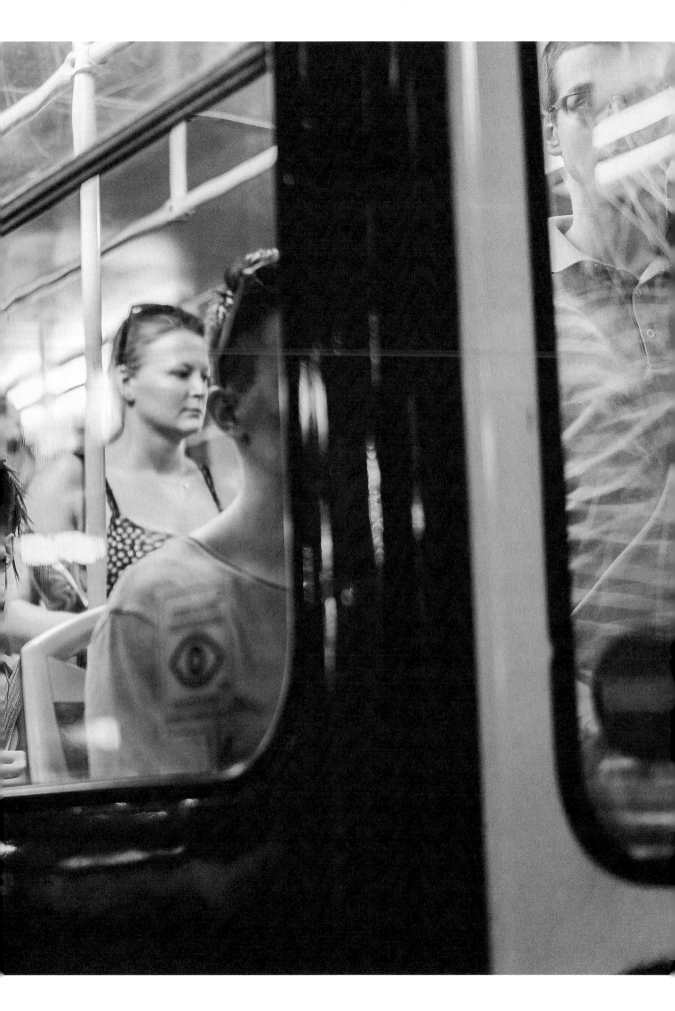

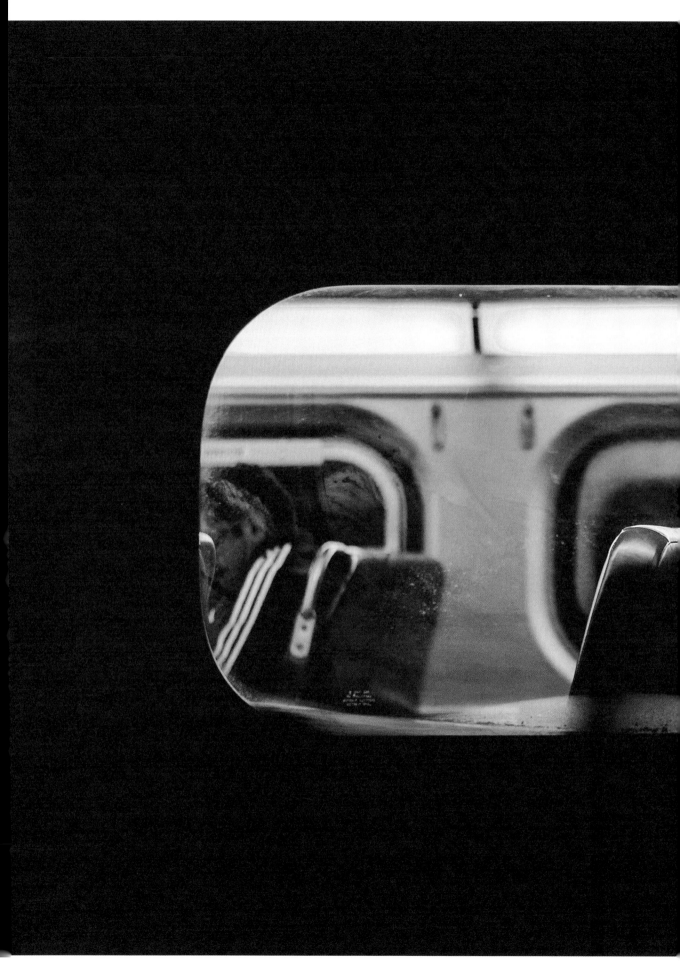

~ I'm so sorry for anyone who has ever hurt you; but please don't close your heart to love

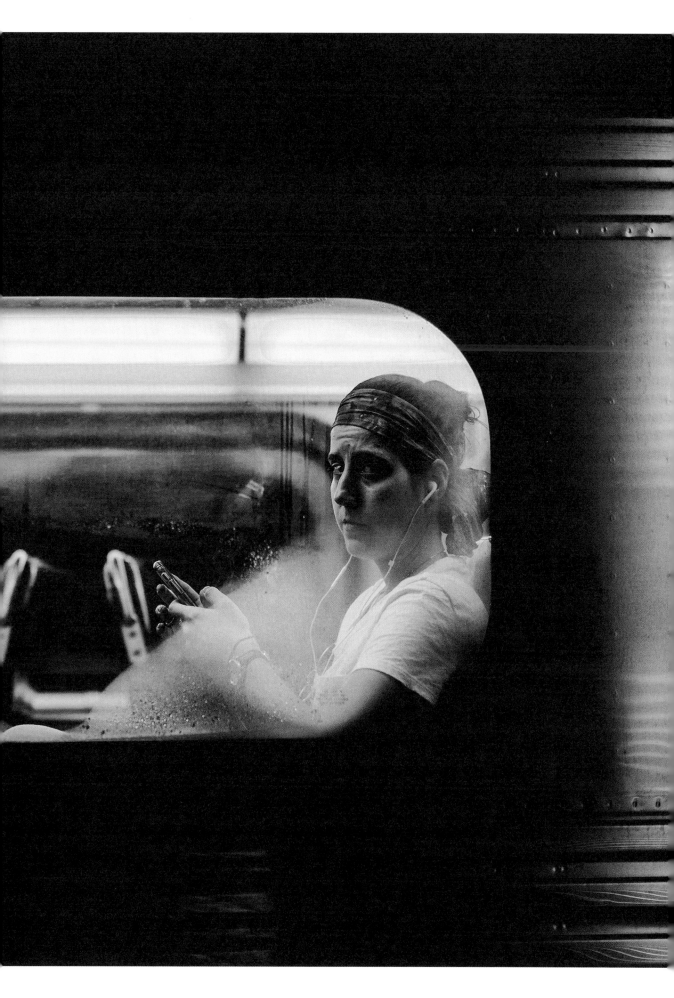

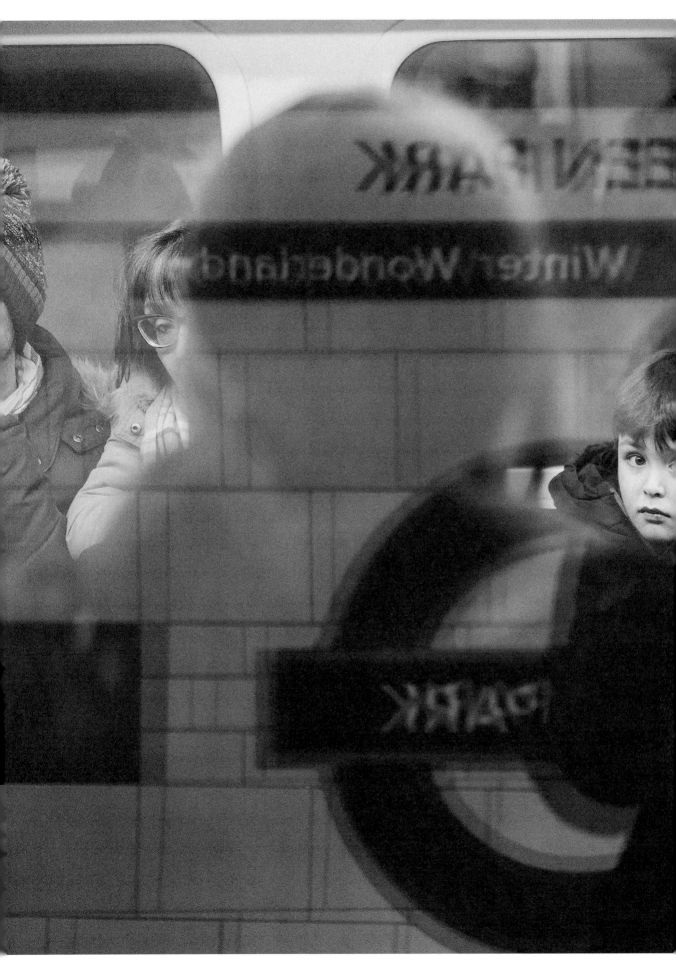

~ my wish for you: I hope one day someone gazes into your eyes & whispers the words 'I love you'

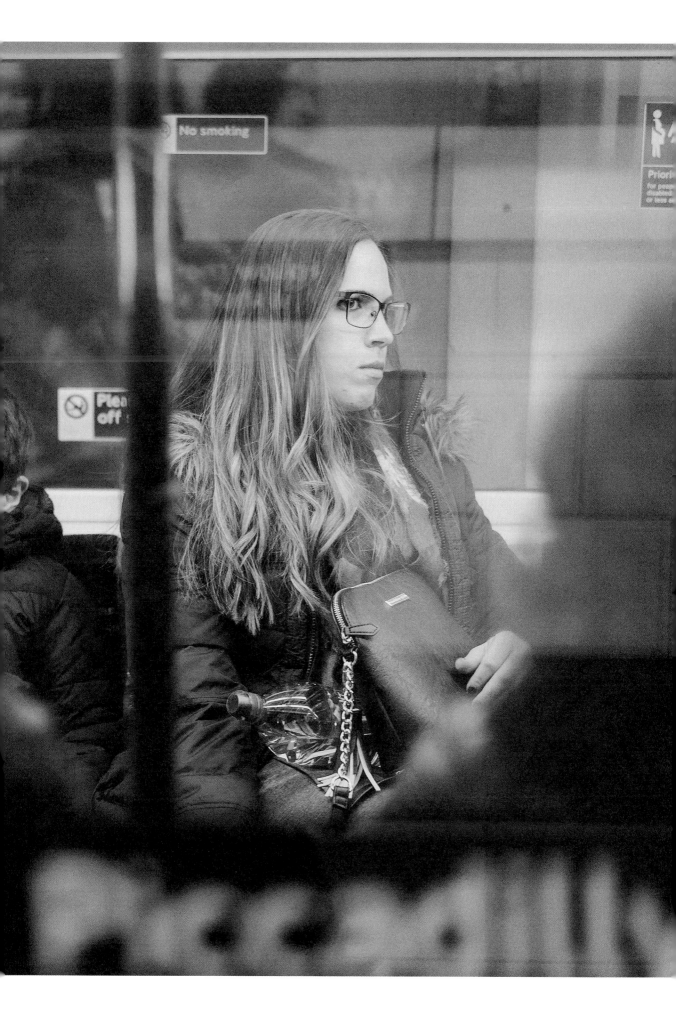

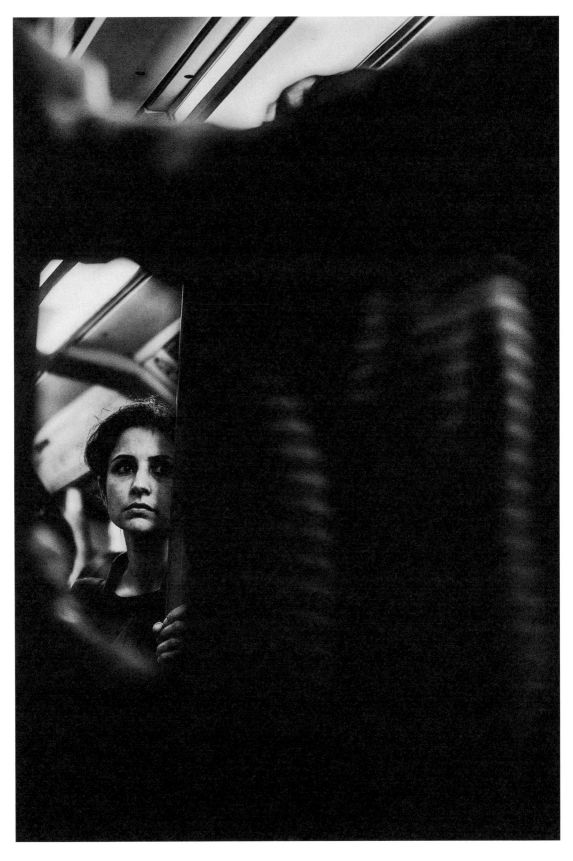

~ it hurts a little & sometimes a lot; but in the end 'we' as in you & I were never meant to be.
And, years from now – maybe even less – you won't even matter

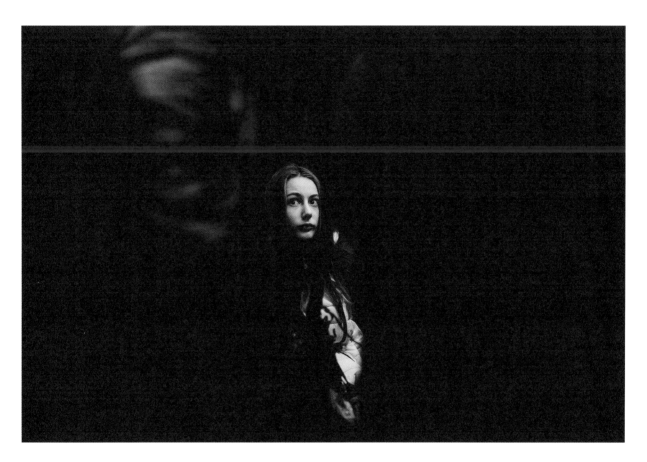

~ dear stranger; trust your feelings. I can't promise you'll never get hurt, but your feelings tell you who you are, so never be ashamed of them

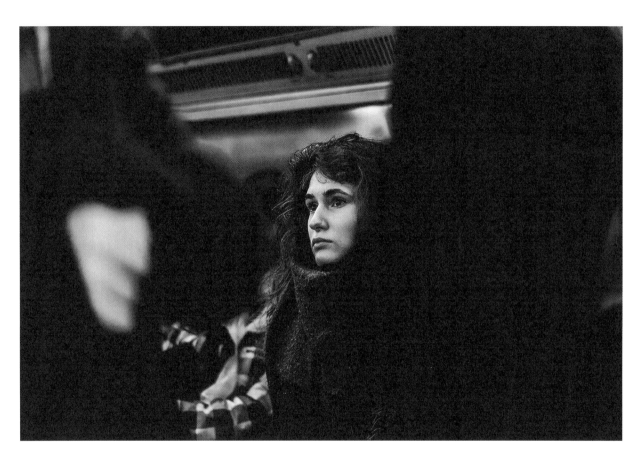

~ locked in a daydream of thoughts & what-ifs

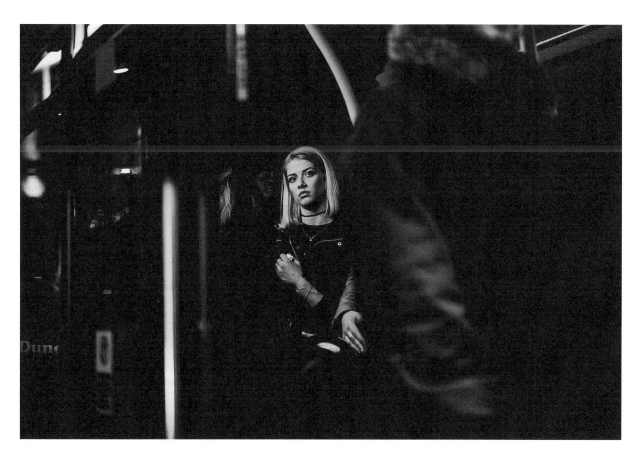

~ don't let anyone trick you into thinking that somehow you're ordinary

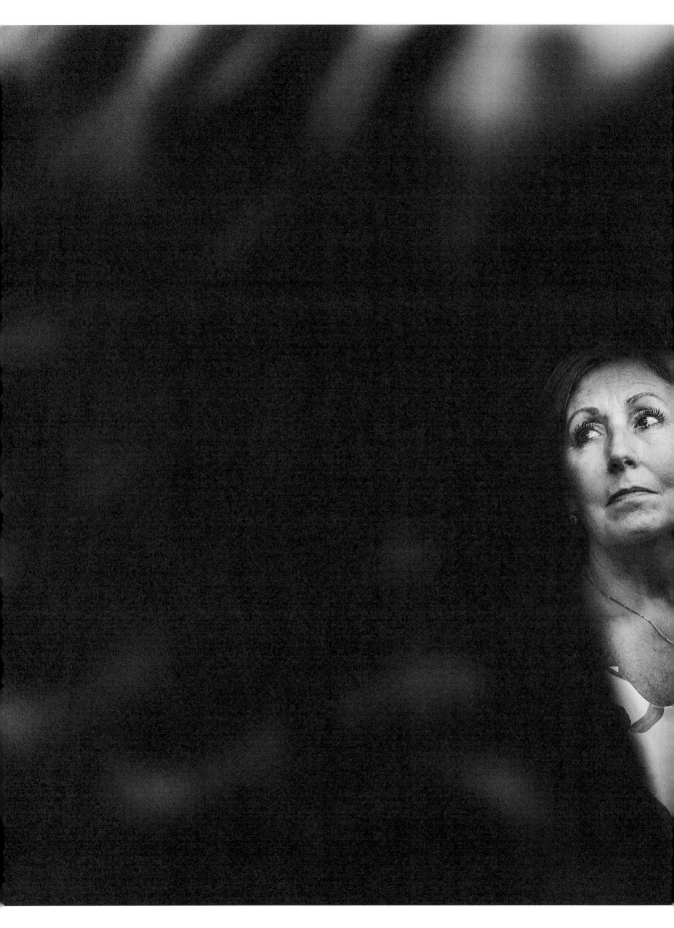

~ I wish we could exist; just you & I, curled up in a soundproof bubble

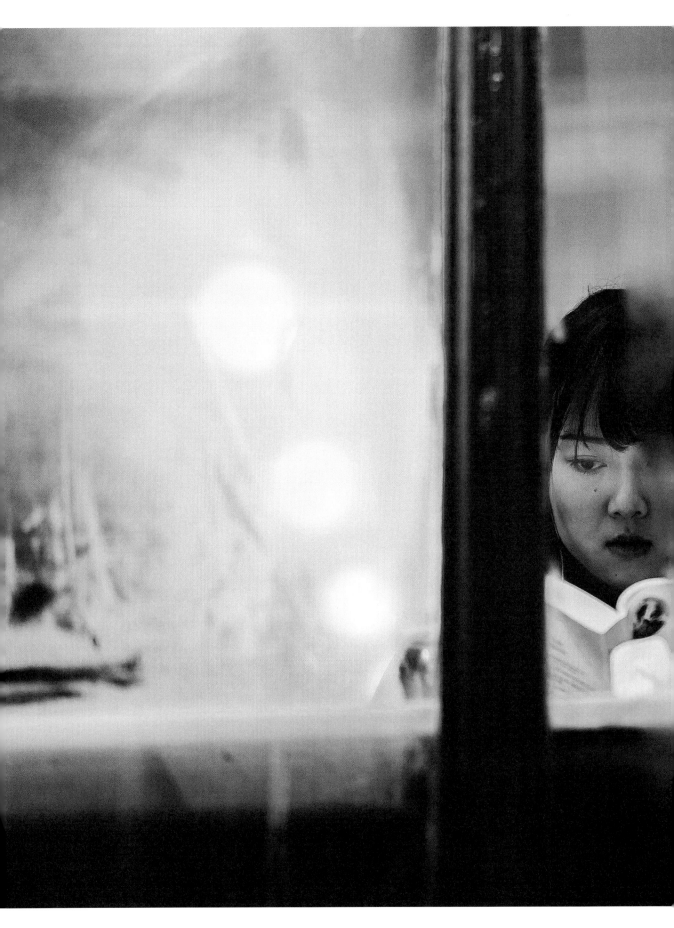

~ and, so I'll sit here passing time until you decide to come into my life again; & repeat this déjà vu

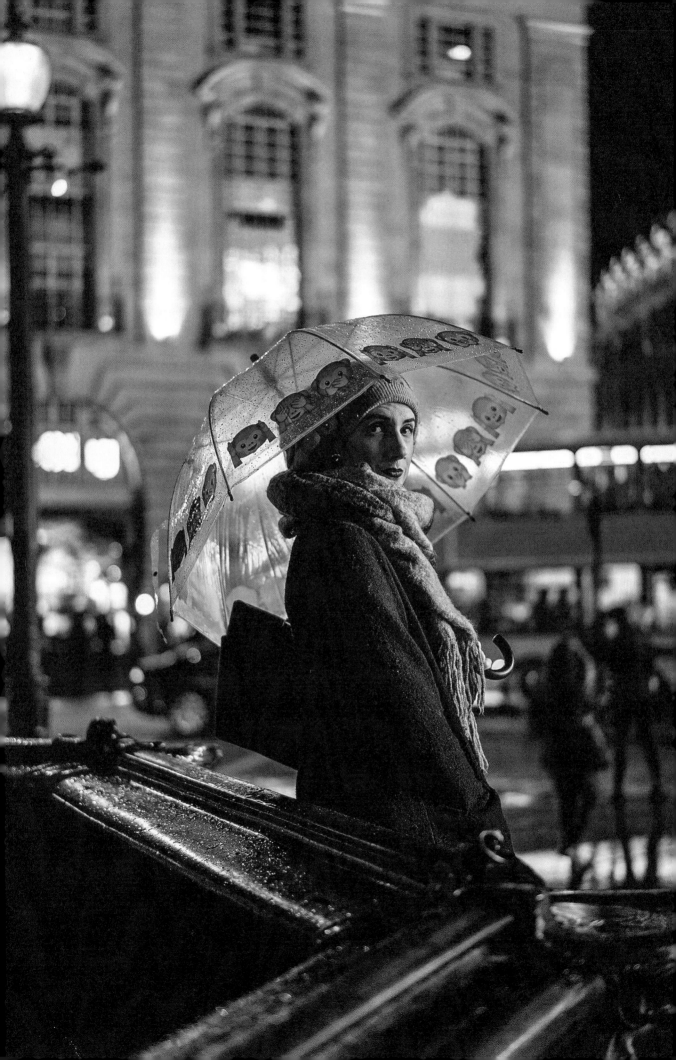

~ there was something in her eyes that I would almost swear
said something more – some deeper sort of curiosity

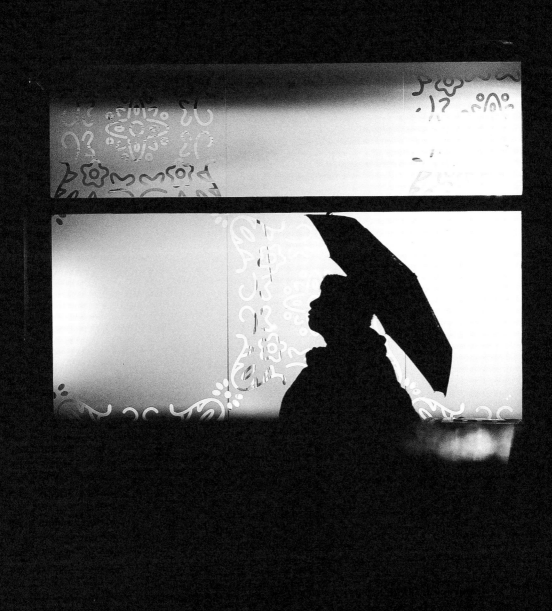

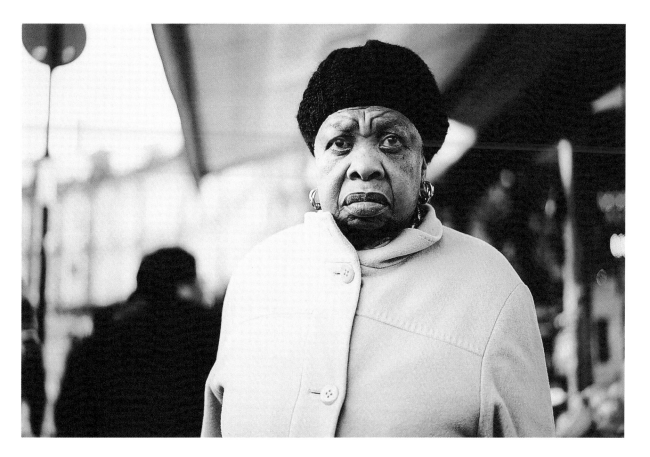

~ you can find something beautiful in an ordinary moment

~ stupid stories; laughing for hours. I never totally believed you. I knew it was always a silly joke.
 But I loved & laughed, because I was laughing with you. We spent too many hours making
 dreams & now we never talk. I miss you, I guess is what I'm trying to say

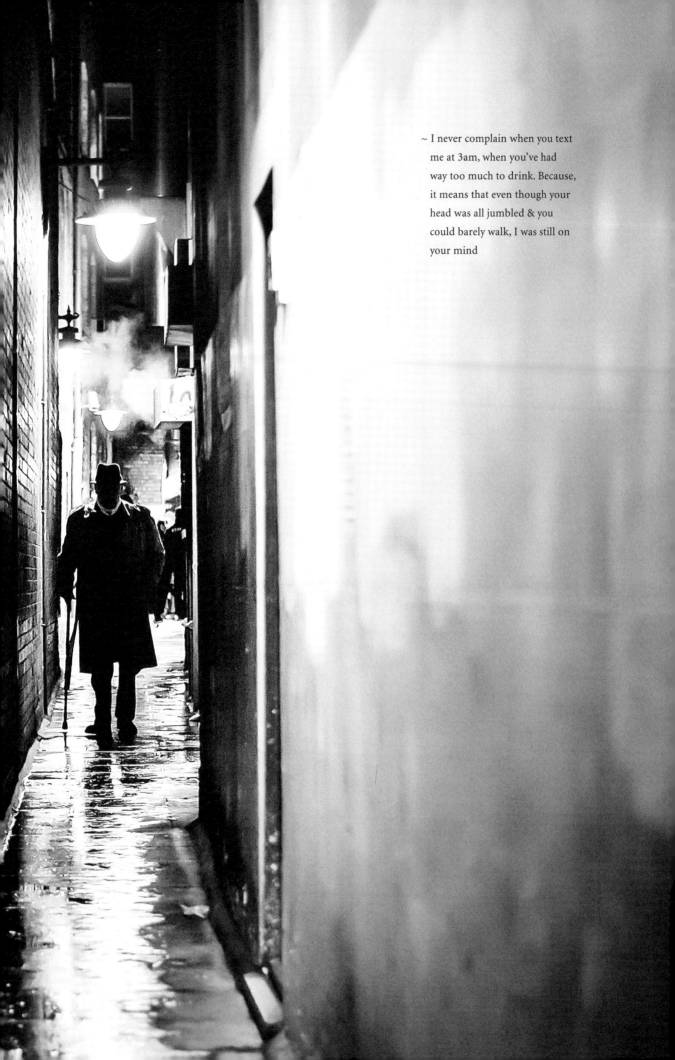

~ I never complain when you text
 me at 3am, when you've had
 way too much to drink. Because,
 it means that even though your
 head was all jumbled & you
 could barely walk, I was still on
 your mind

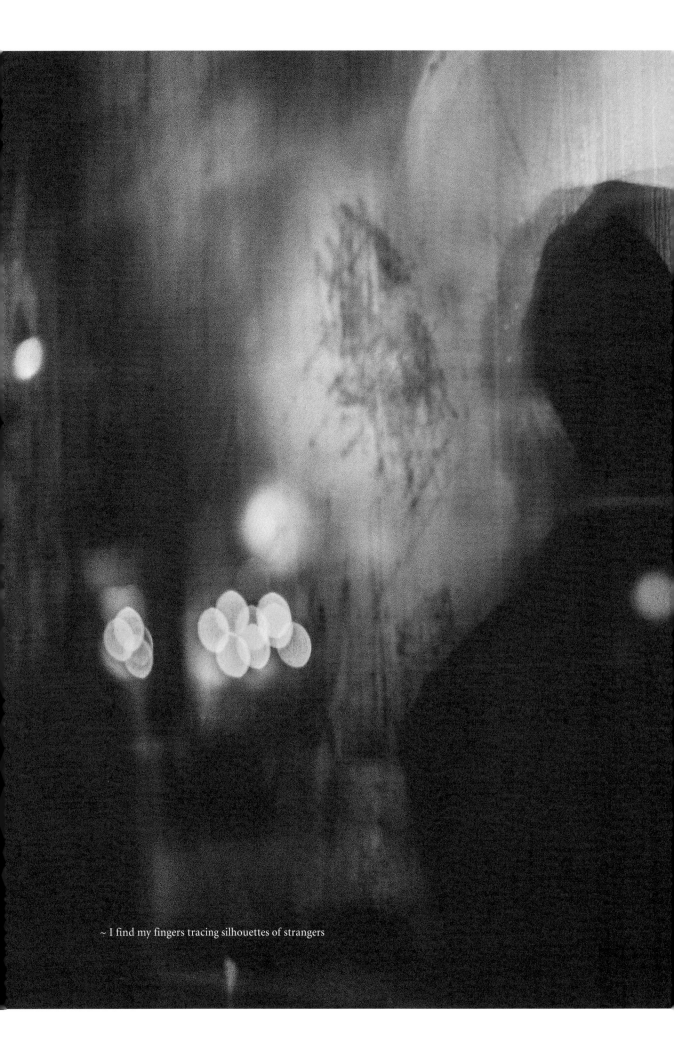

~ I find my fingers tracing silhouettes of strangers

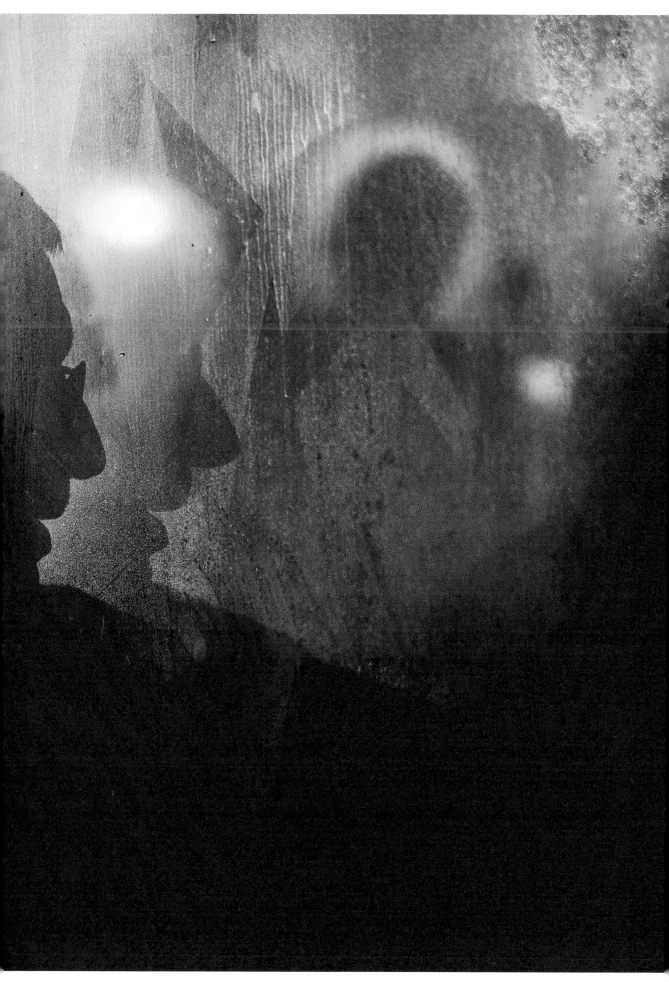

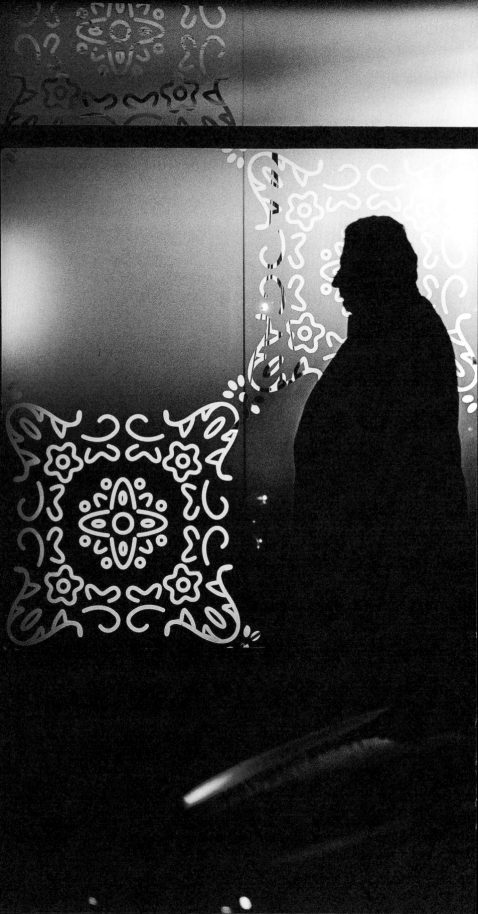

~ some nights when I walk home,
my eyes squint through the
darkness hoping to see you
walking towards me too, under
the streetlights, but you never are

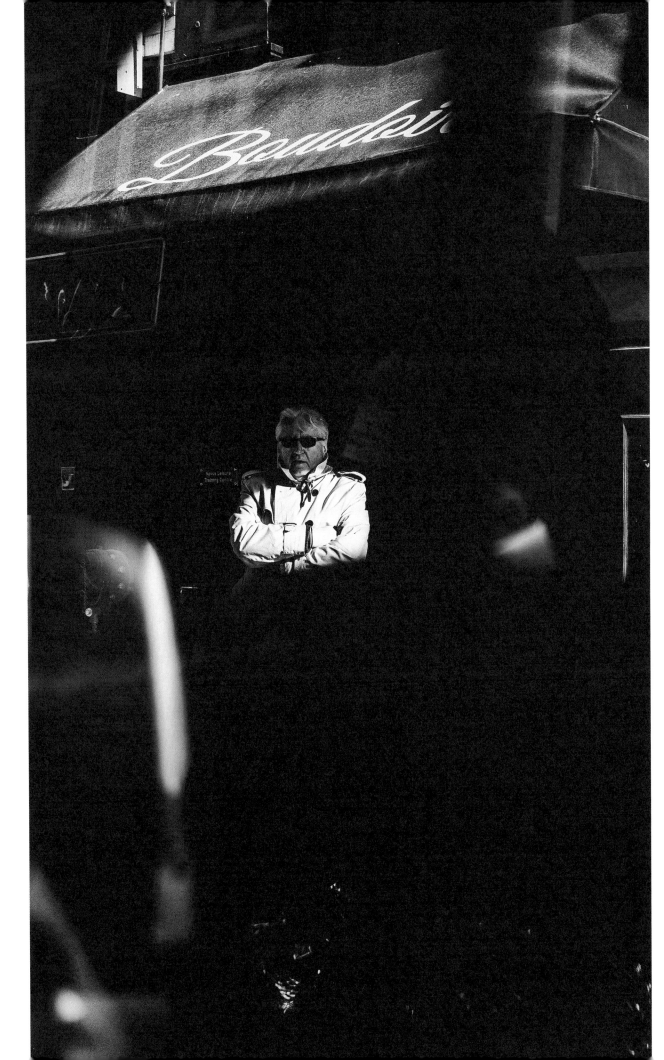

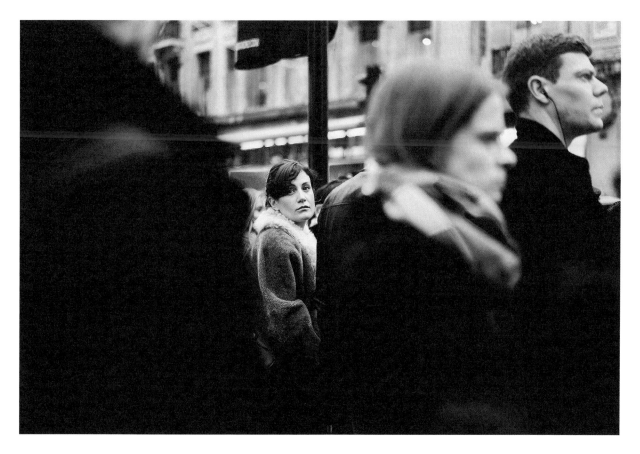

~ sometimes I feel like I'm falling apart; desperate to love & to be loved. Continuously searching
for people in places & memories in moments that will fill the cracks in my broken pieces

~ you don't have to love me back; just say I see you & we'll let that be that

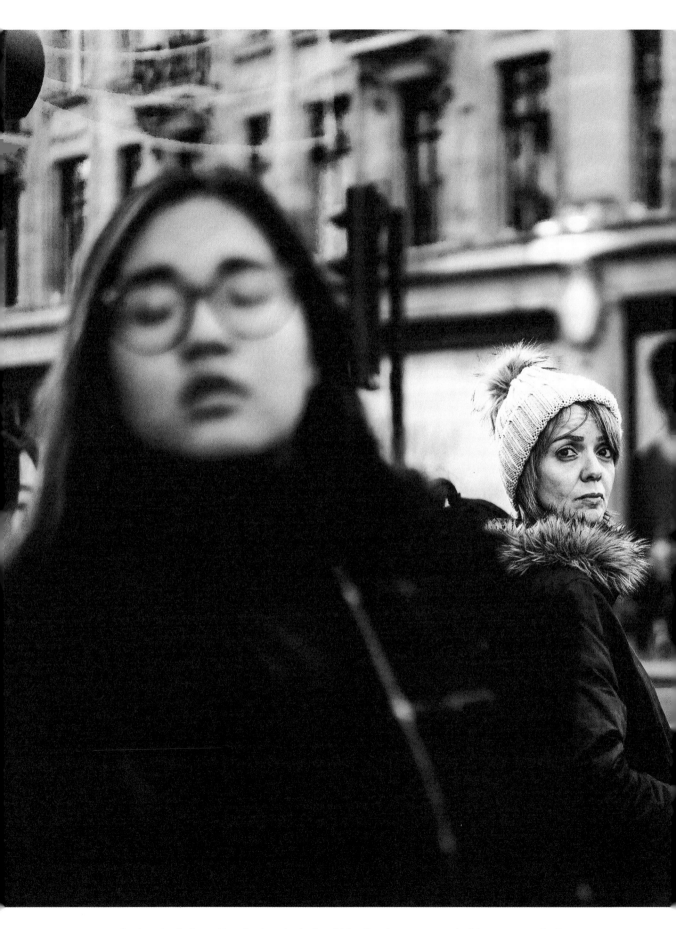

~ she thought she knew him; she thought she loved him. But she was wrong. And he was wrong for her

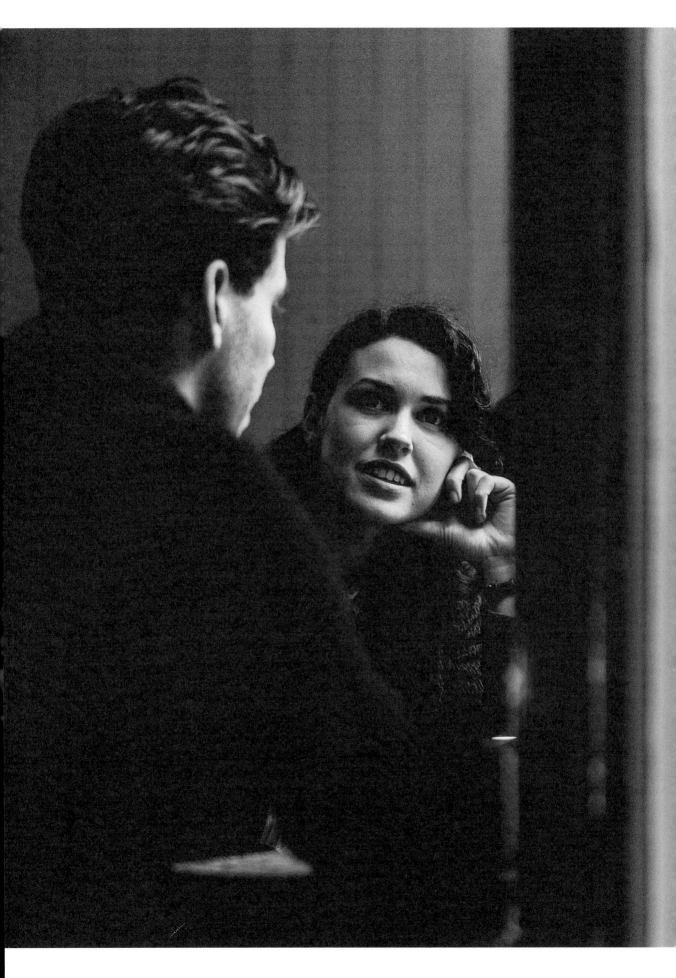

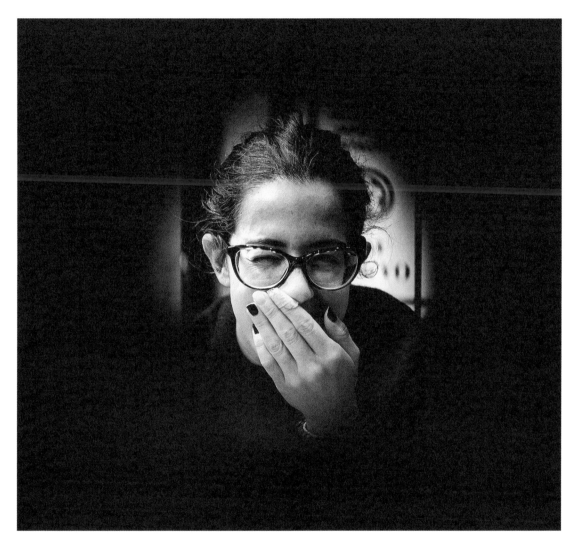

~ there are things in her life she tries to hide. She's wild & chaotic, & laughs along to teasing
jokes; but once you know her secrets, she is different

~ I fear that I'm going to lose you; that I'm going
to close my eyes; that I'll forget where I am;
that I'll look behind me... And when I finally
remember where I'm at, you'll be gone

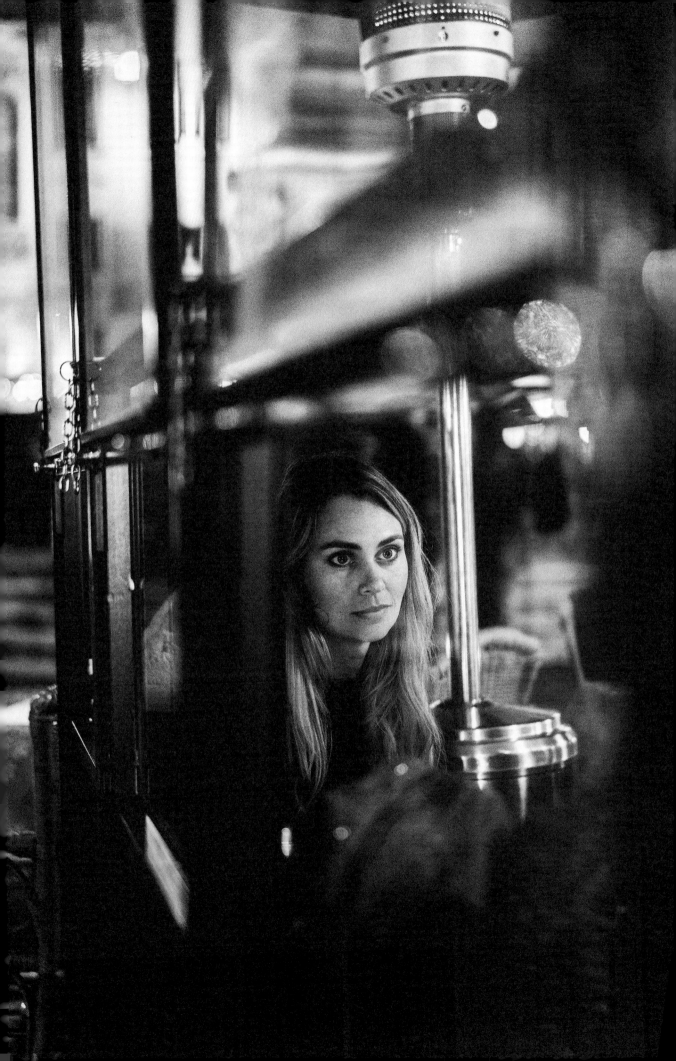

~ notes to a stranger; not everyone has the ability to understand you; eventually your scars won't cut so deep; you are worth much more than you think; don't seek to find love, let it find you

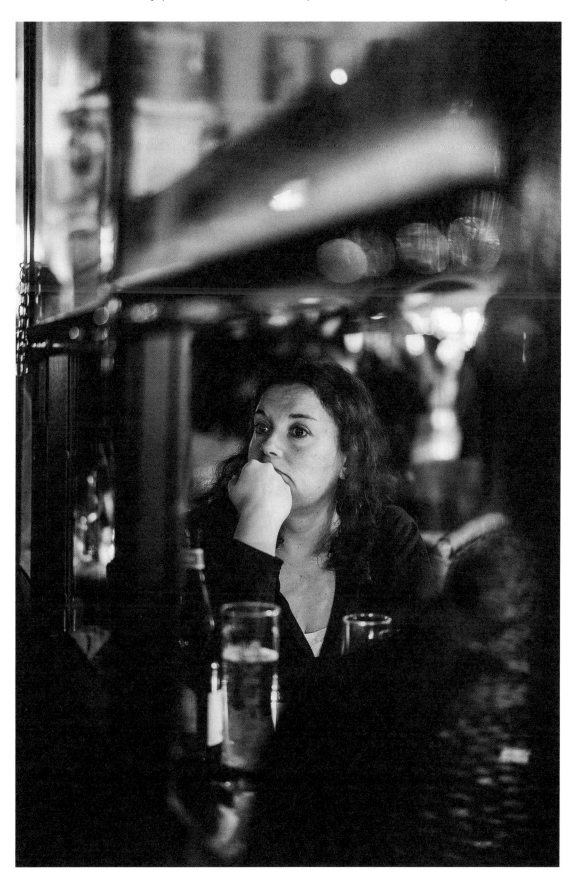

~ no matter how much I guard my heart, you already own it without even knowing

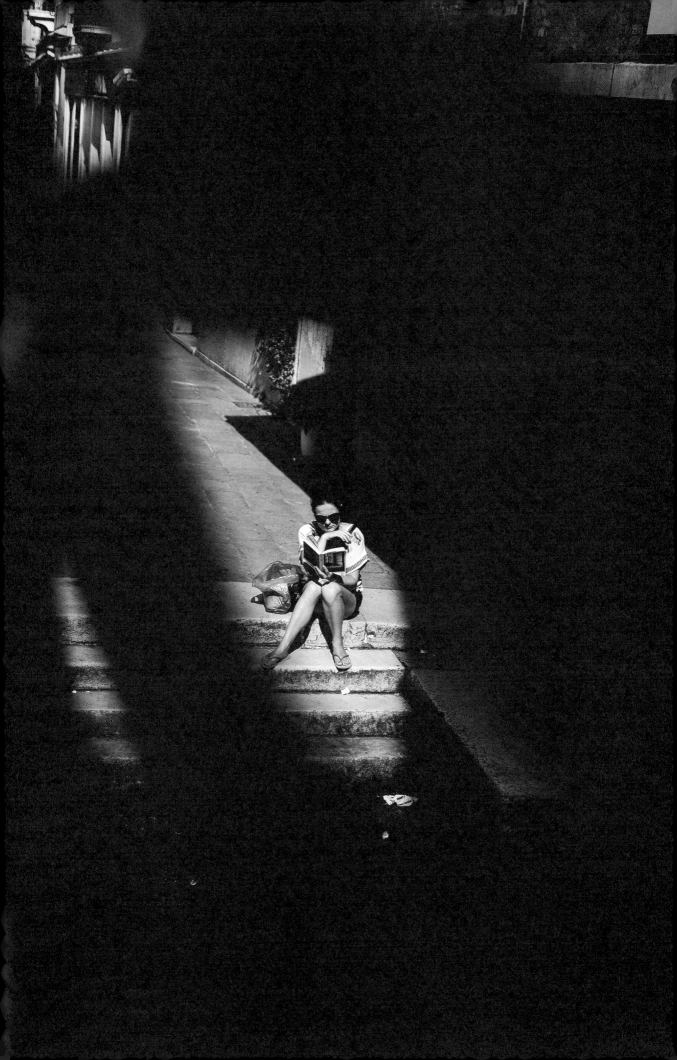

Stealing Time

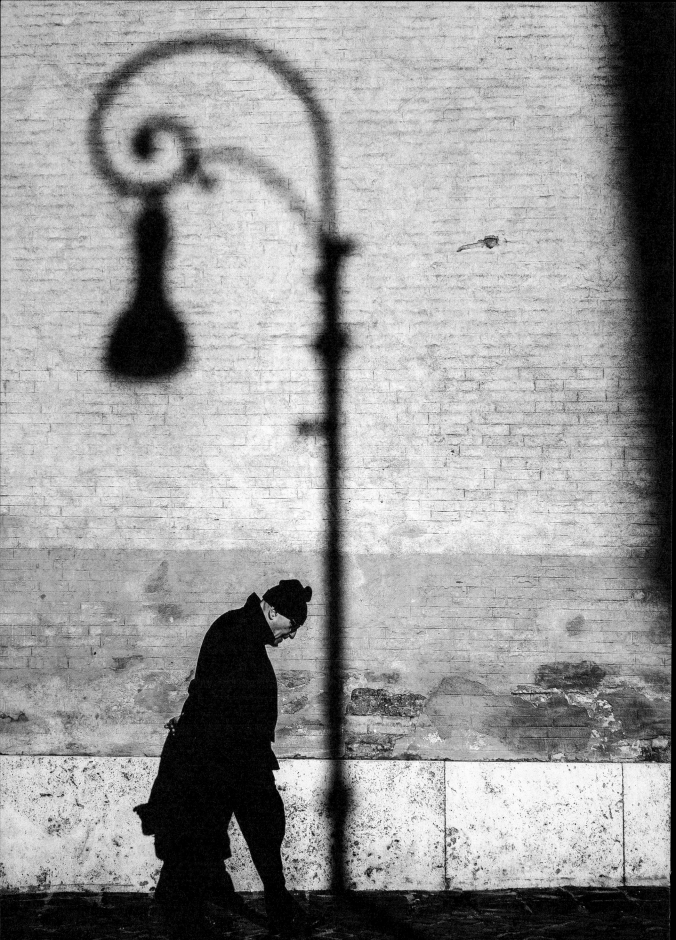

Every nanosecond, of every day, all over the world, stories are being played out in front of us – all going untold. But are they? When your imagination takes over, you can put yourself behind the camera and imagine the scene.

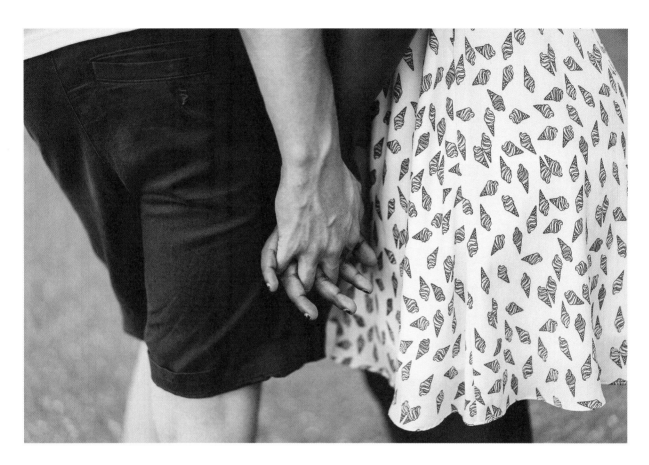

~ hand holding is such a beautiful thing; two different hands intertwined to make one...

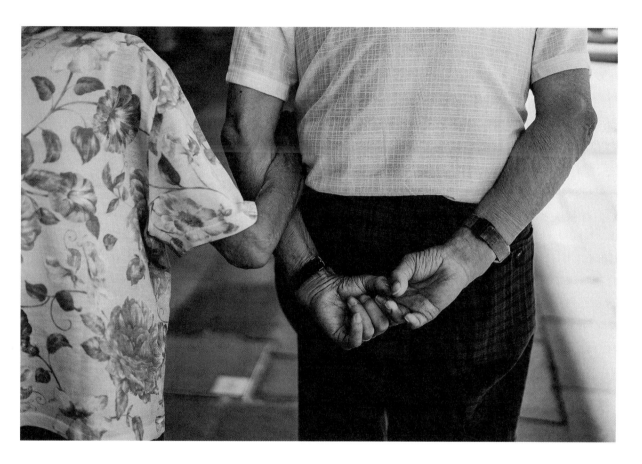

~ love who you have while you have them, that's all you can do

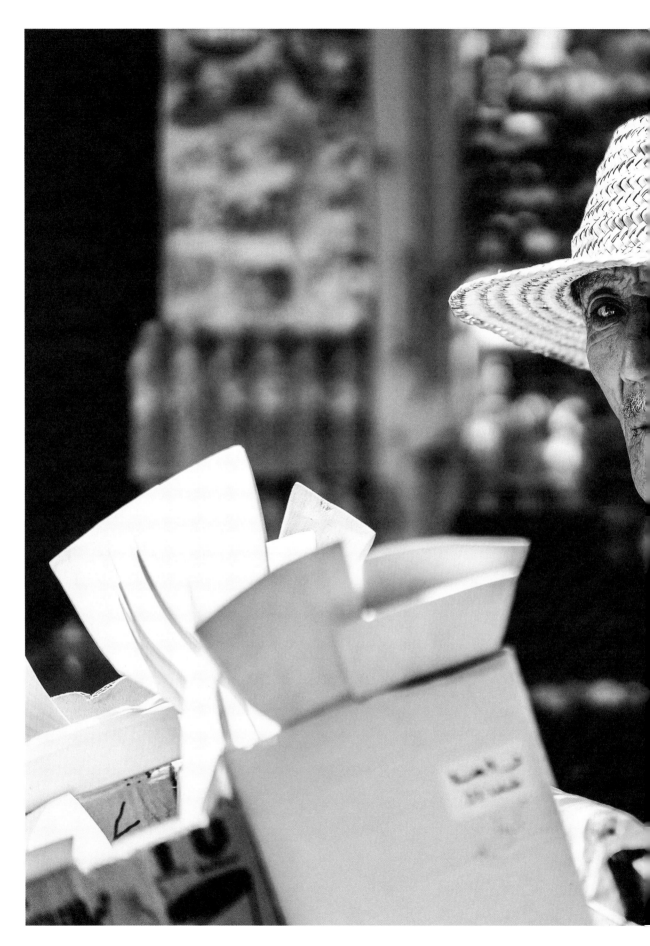

~ I want to be looked at by a stranger with caring eyes; I want to be noticed biting my lip or pushing my glasses up the bridge of my nose; I want to be thought about days or weeks later & pondered about who I am & what I love

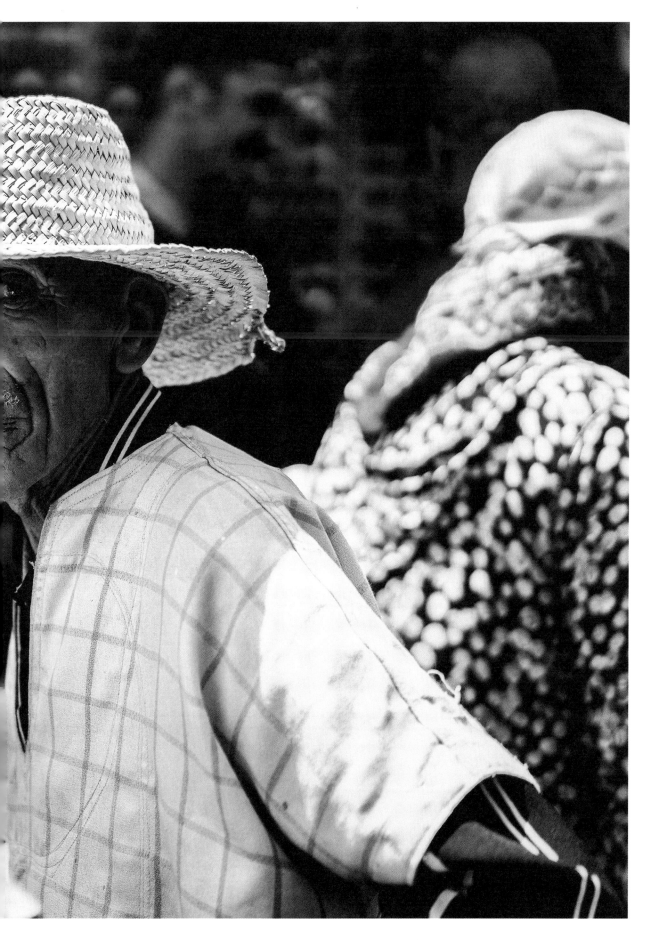

... to them I am just another face, but to me, they're something quite beautiful

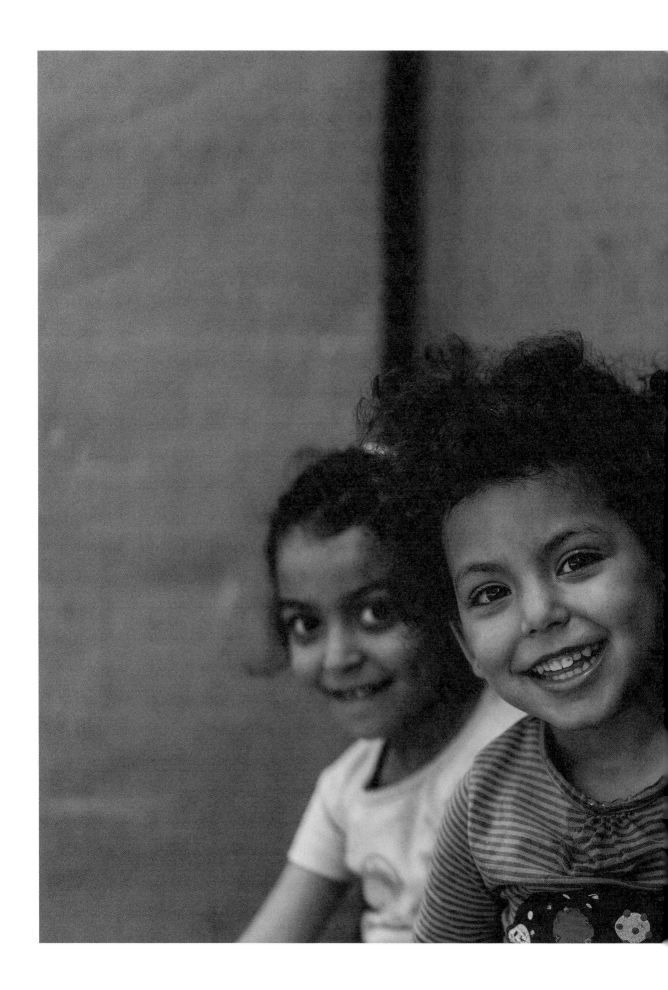

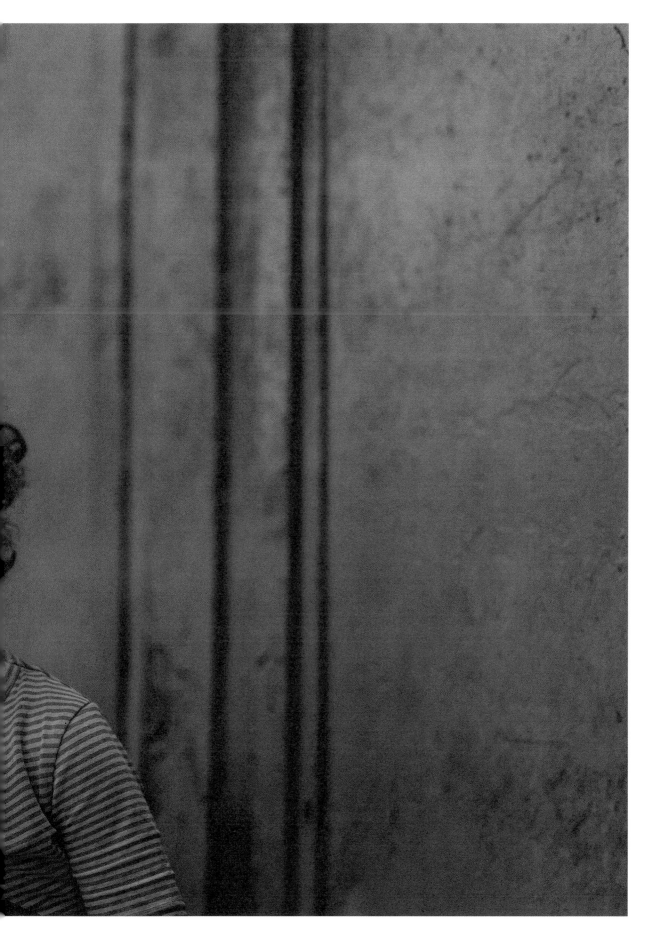

~ as I looked at you looking back at me, I wondered about the curious little thoughts swimming around
inside your head & whether you'd remember this moment like I was remembering it

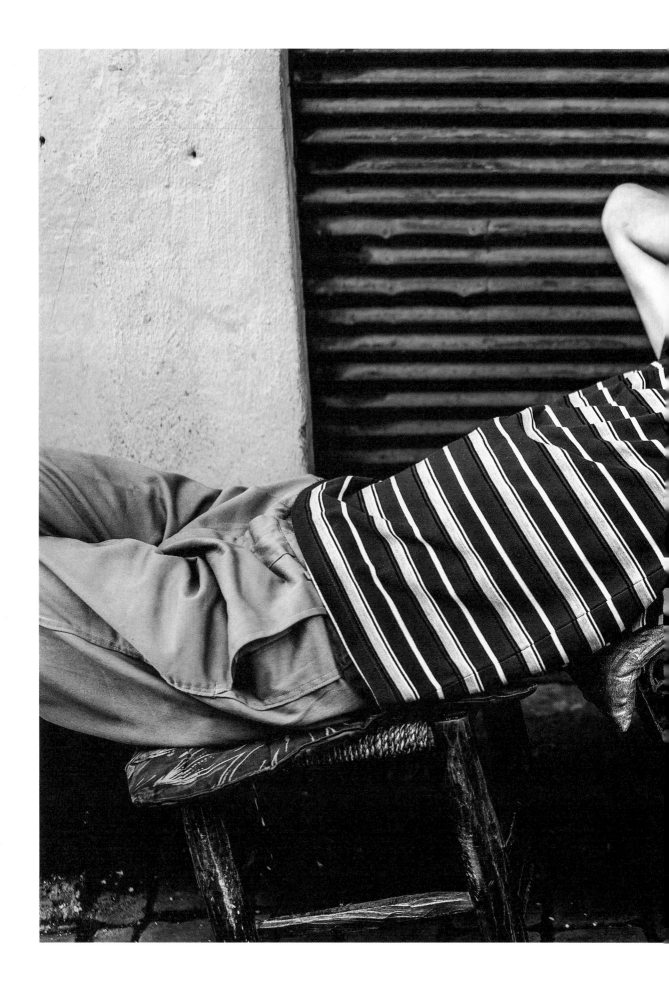

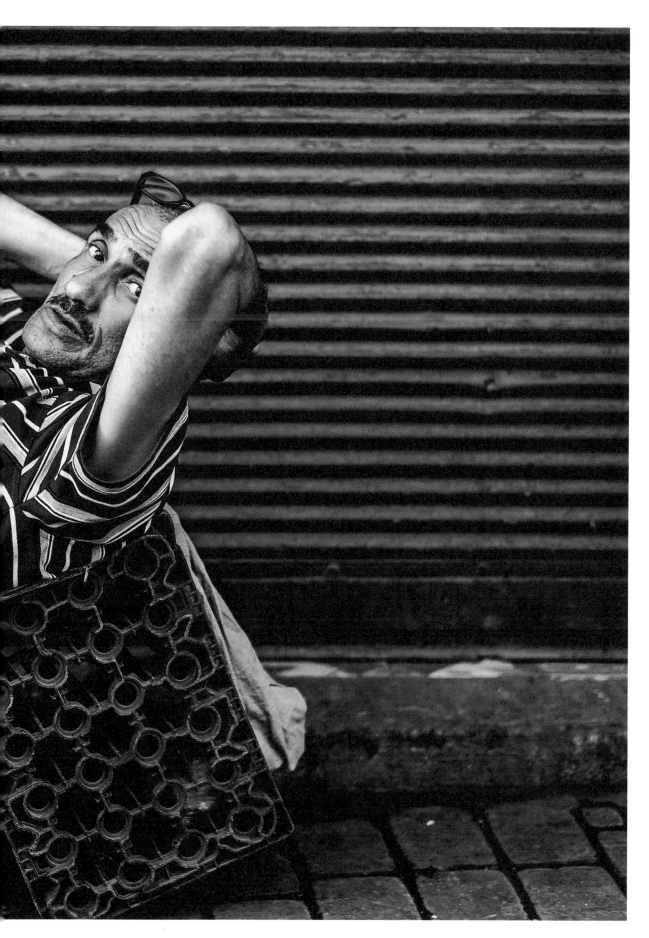

~ ripped out of his comfortable little daydream & pulled back into reality; sometimes he thought to himself,

'she's out there wandering the world & that maybe with some patience and luck, I'll meet her one day'

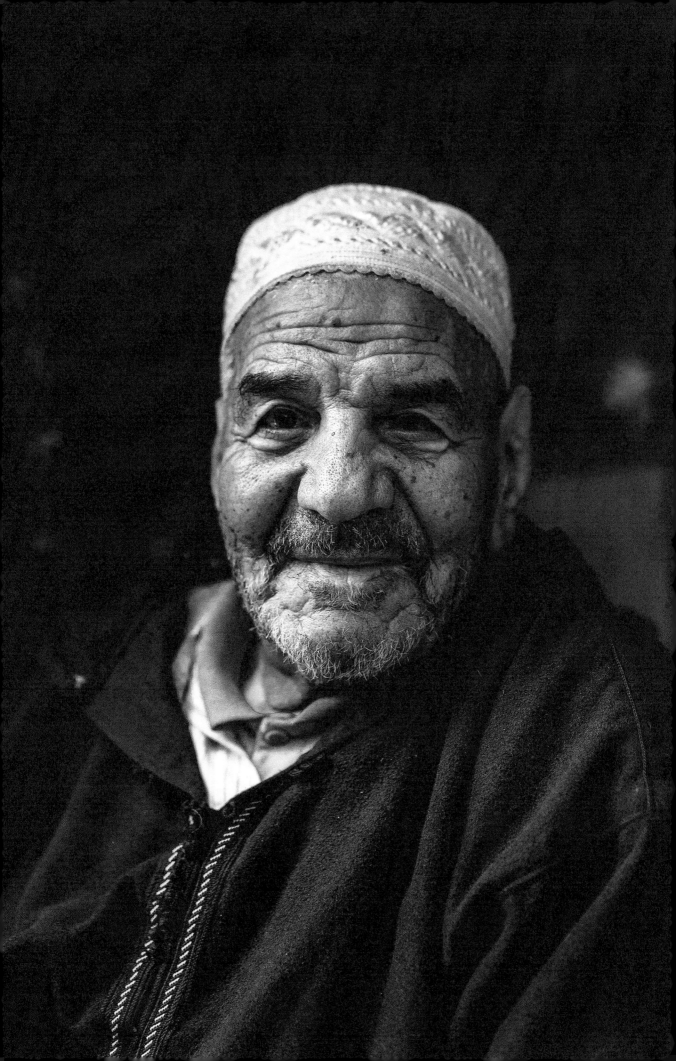

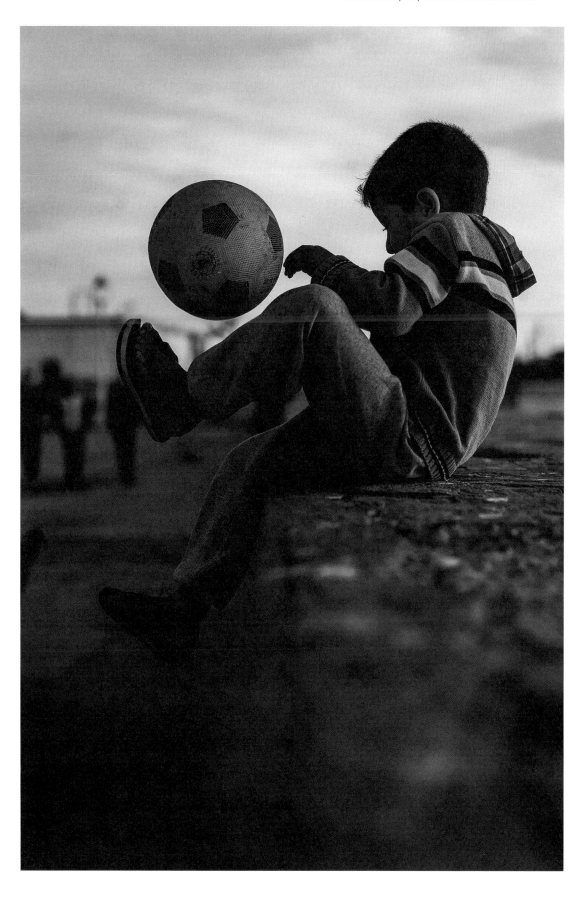

~ we were looking at each other & I could see the corners of his eyes start to crinkle. Sometimes all
 that any of us want, is for someone to notice us, to say hello & to offer up a friendly smile

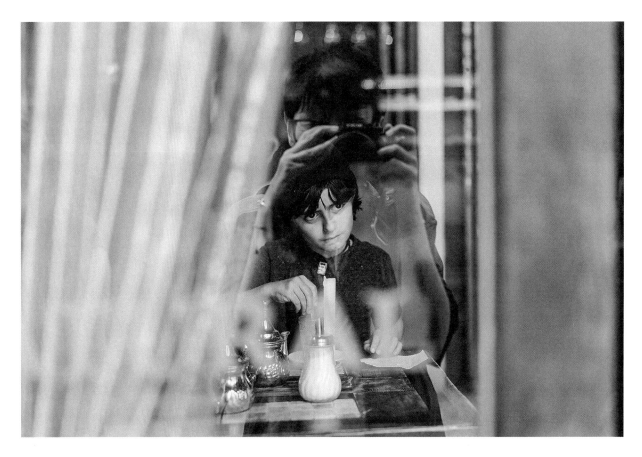

~ he's the growing hero of his own life story; he's the love of someone's life & what he can
 do may change the world

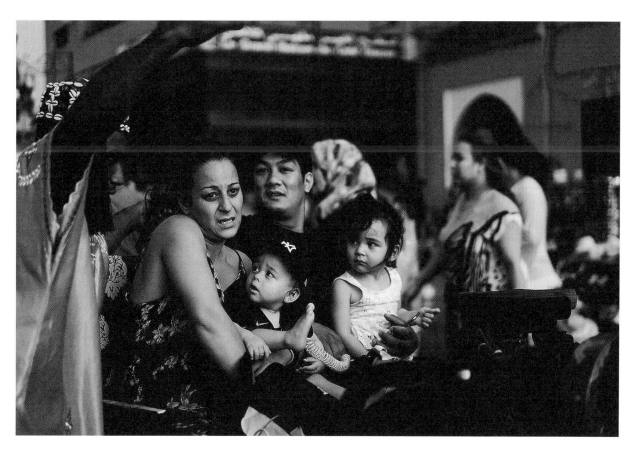

~ take away the distraction, remove the fears & insecurities & perhaps you'll see the person deep inside. The one who's always been there

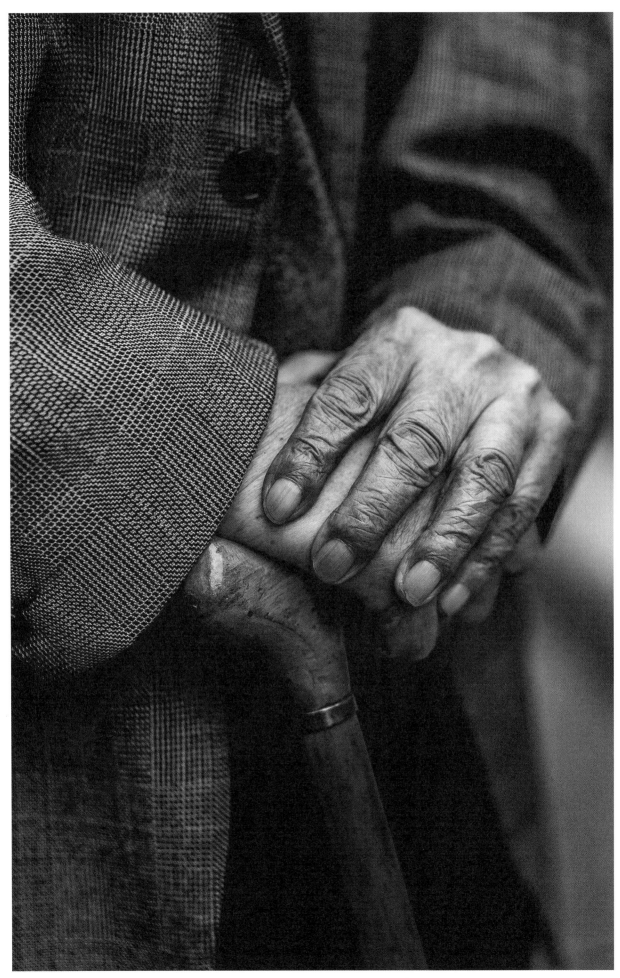

~ he noticed me, then asked 'why do you take photos?'
'to empty my head & make sense of the world around me'
I replied

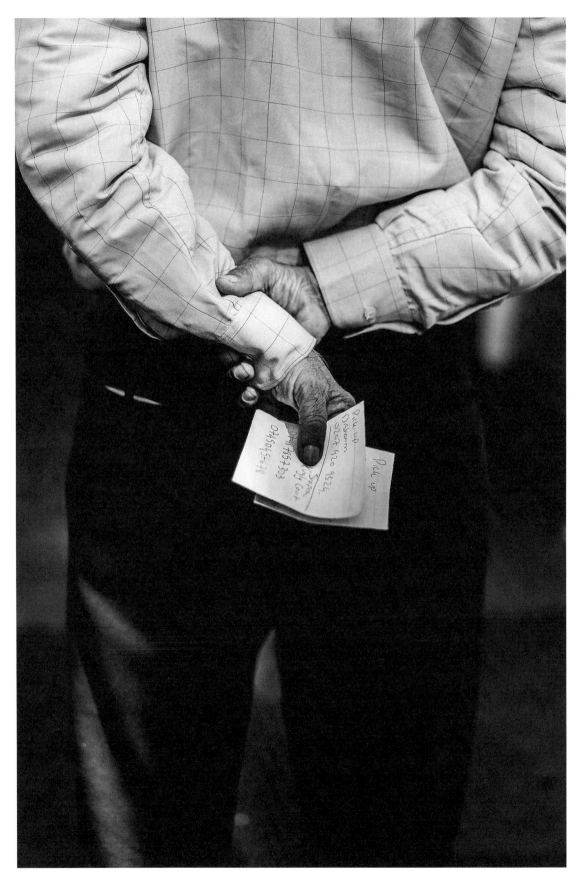

~ you stood there quietly with your scribbled note; patiently waiting & watching.
 Curious eyes earnestly gazing in every direction

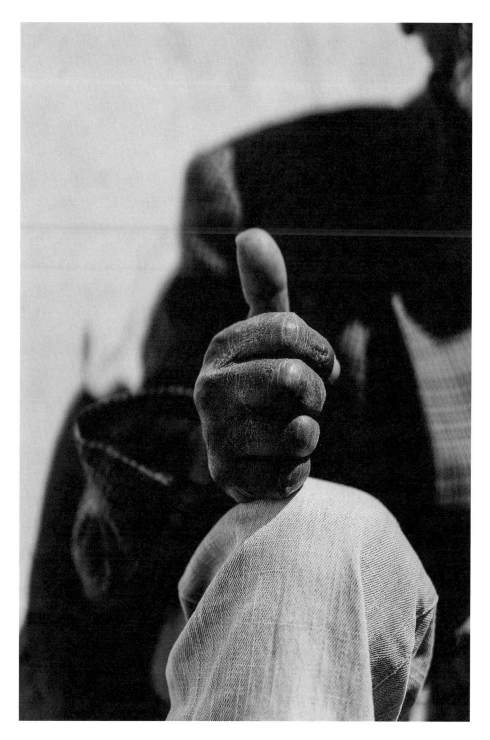

~ dear stranger; to me you seemed like a drifter, a shadow; there one minute, moving on the next. Always watching, always waiting. Loved by some, a little misunderstood & despised by others. But never really caring. And, I know you won't remember this day, or me, but I will

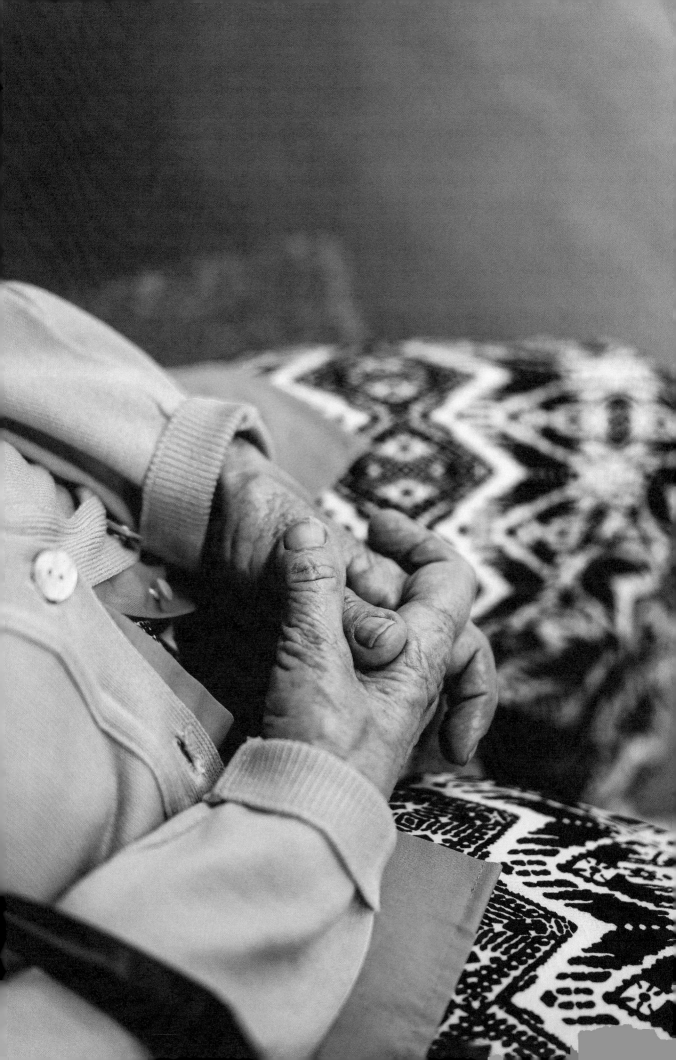

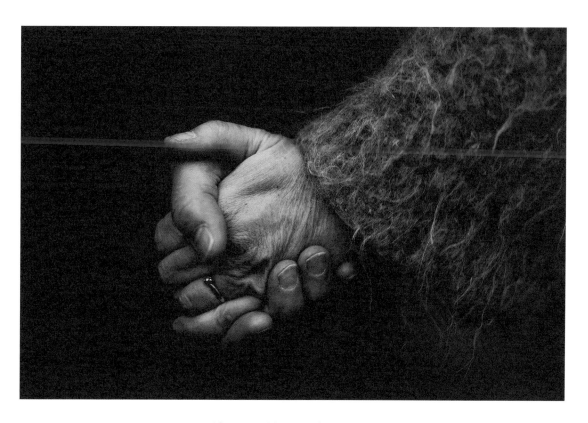

~ it's at times like these, I'm completely convinced that you are my answer

~ she drank champagne out of a coffee mug; had daydreams
 at night & nightmares during the day; her eyes spoke of a
 thousand thoughts all trying to make sense & her lips whispered
 stories that only she would understand; she danced through
 time in her memories & time danced through her

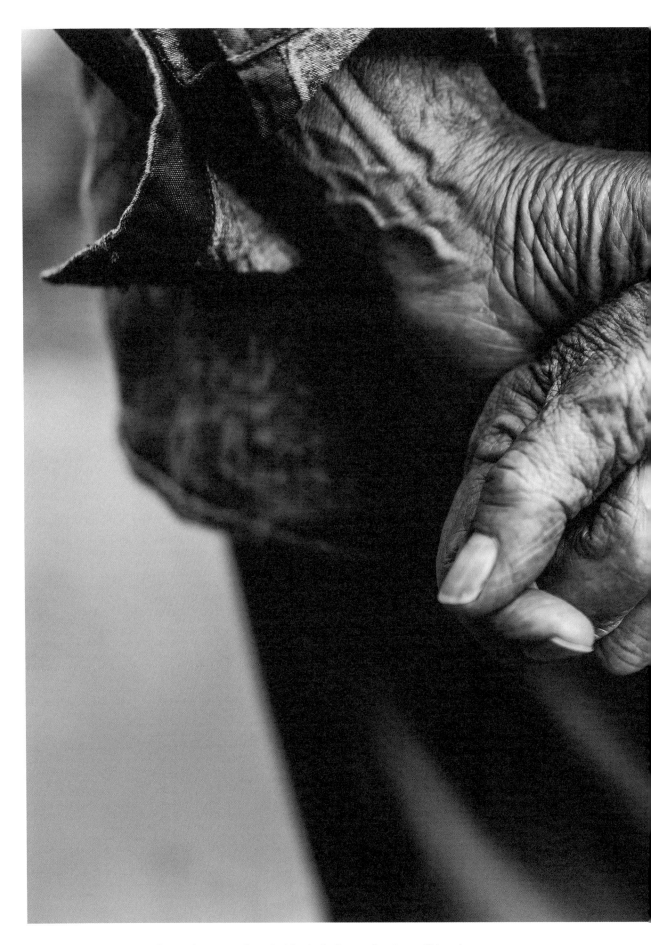

~ whoever; you're out there somewhere. Besides, logic dictates that there will be others

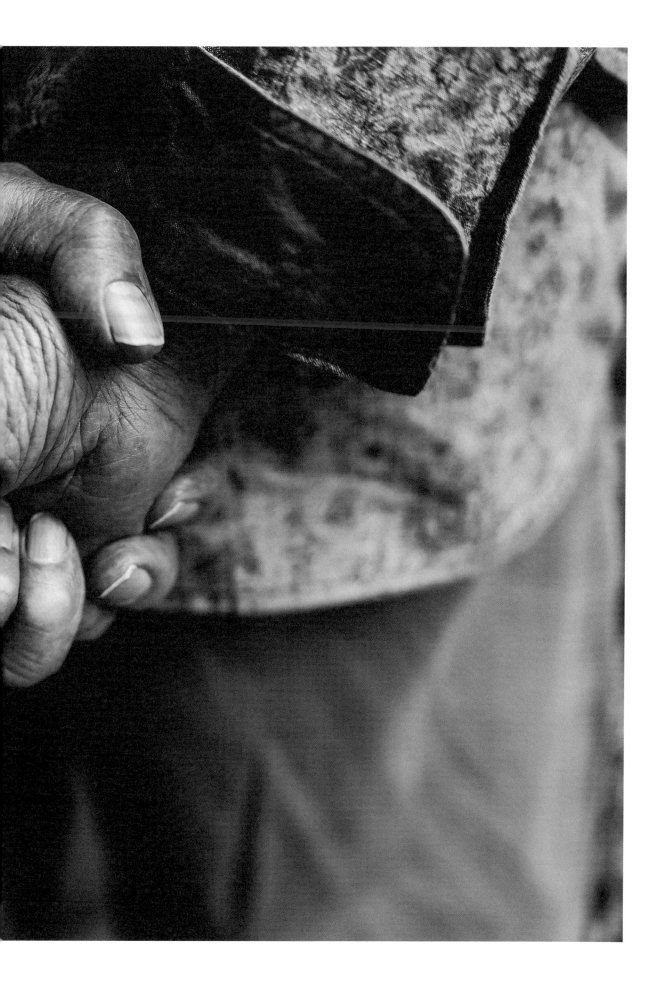

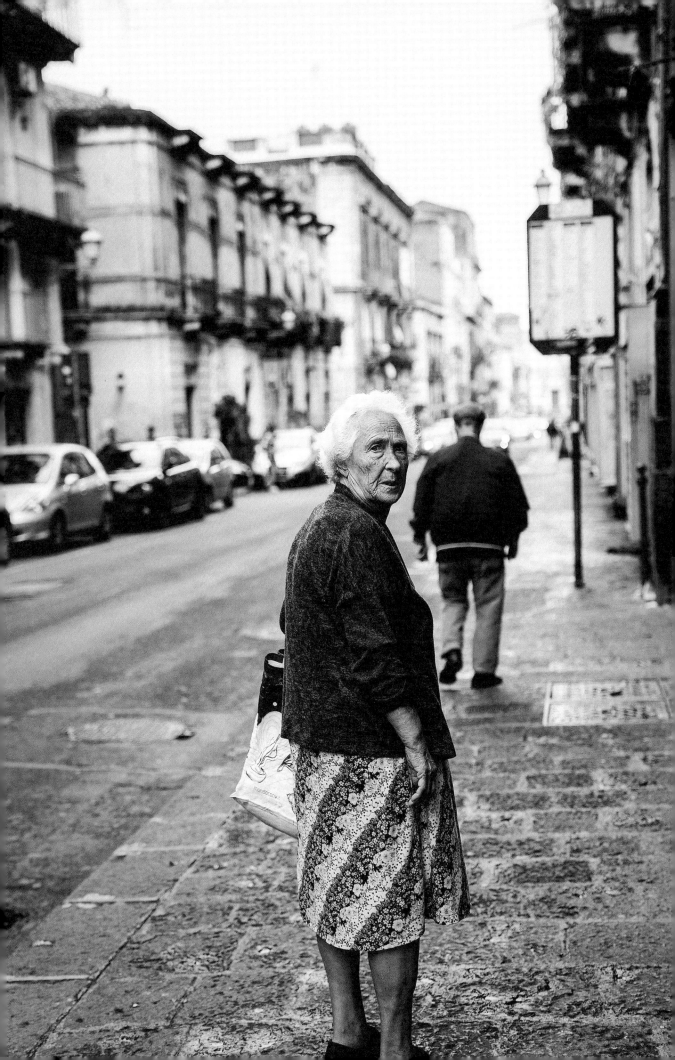

~ you'll be the love of my life until our memories fade away;
then we'll walk through the streets & be strangers again

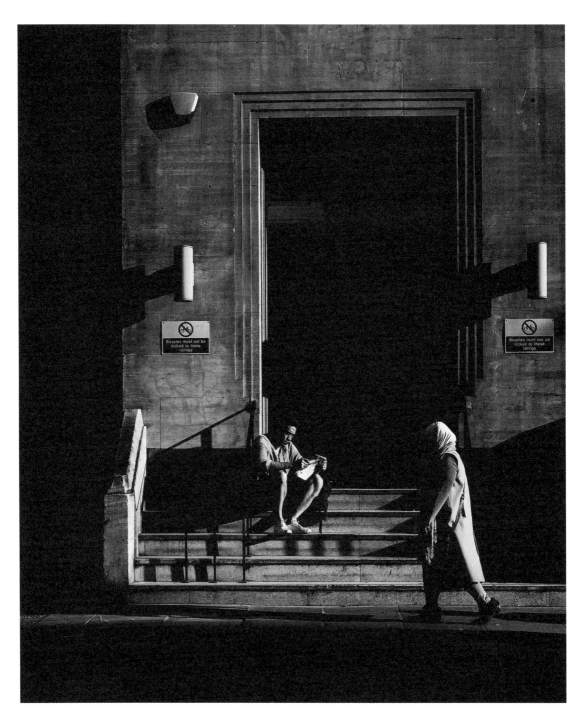

~ but now, you are nothing but a piece of my past; a memory that is constantly fading. I know
you loved books & milk tea. You loved so many things. And, I'm sure you even loved me...

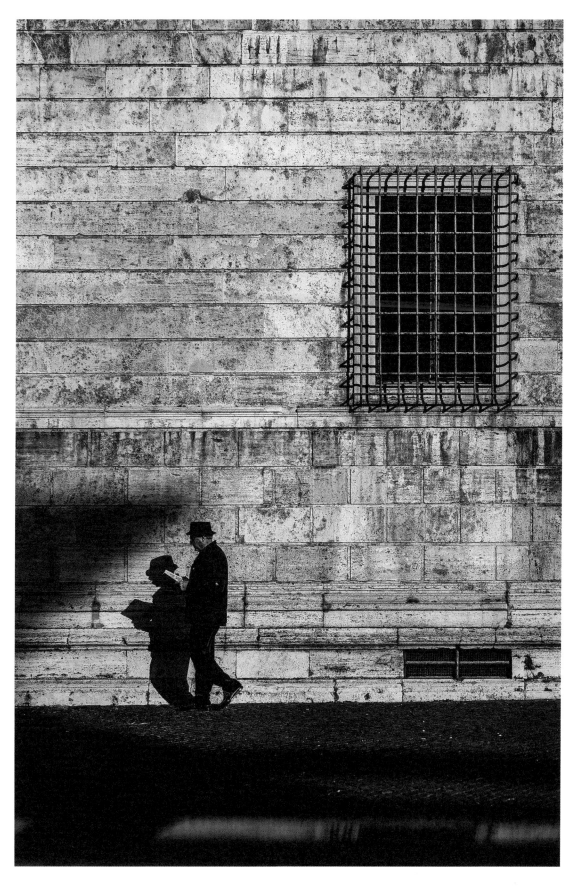

~ I like to think I know you; but what if I don't?

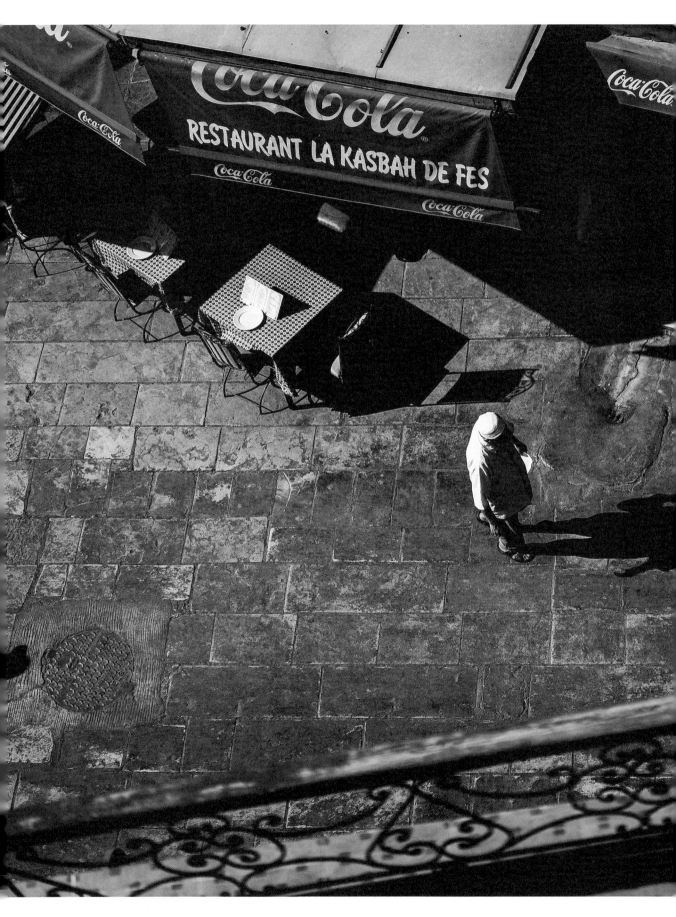

~ as he saw her face amongst the crowds, he wondered if he would ever see her again; curiosity got the better of
him & he followed her through the hundreds of faces; he started walking faster & faster; & then when the street
cleared her face was gone, just like it had been for years

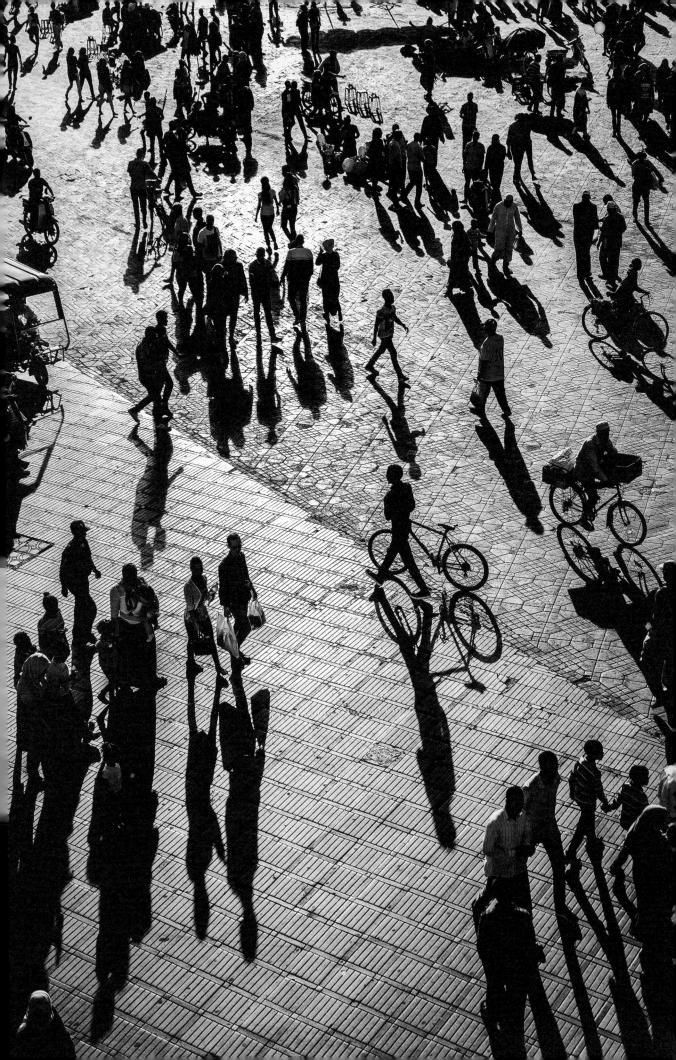

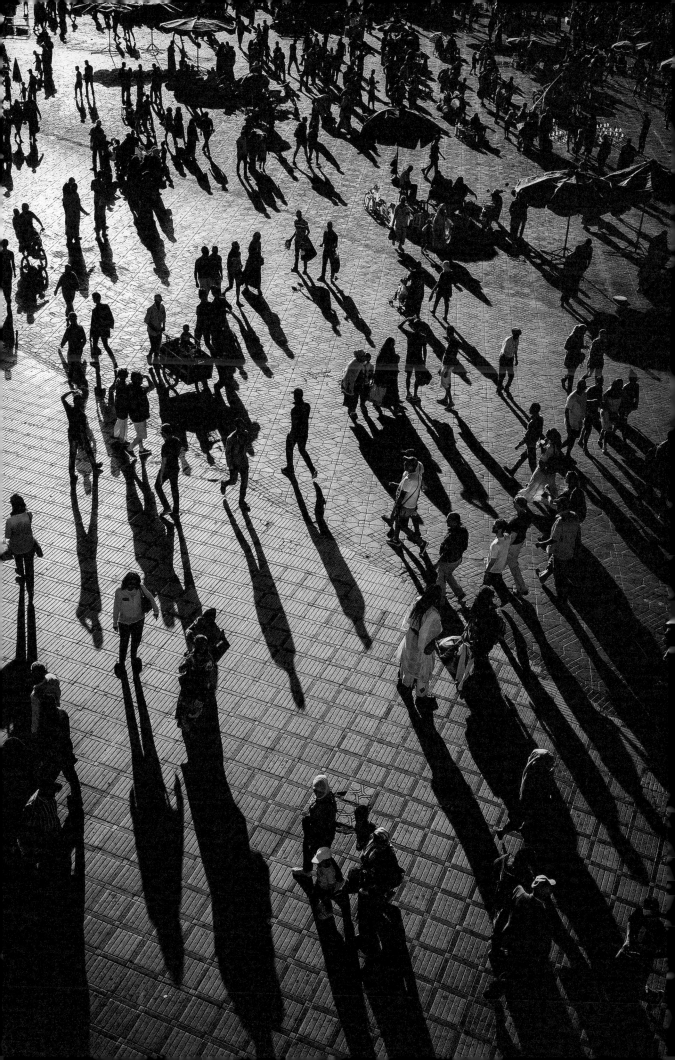

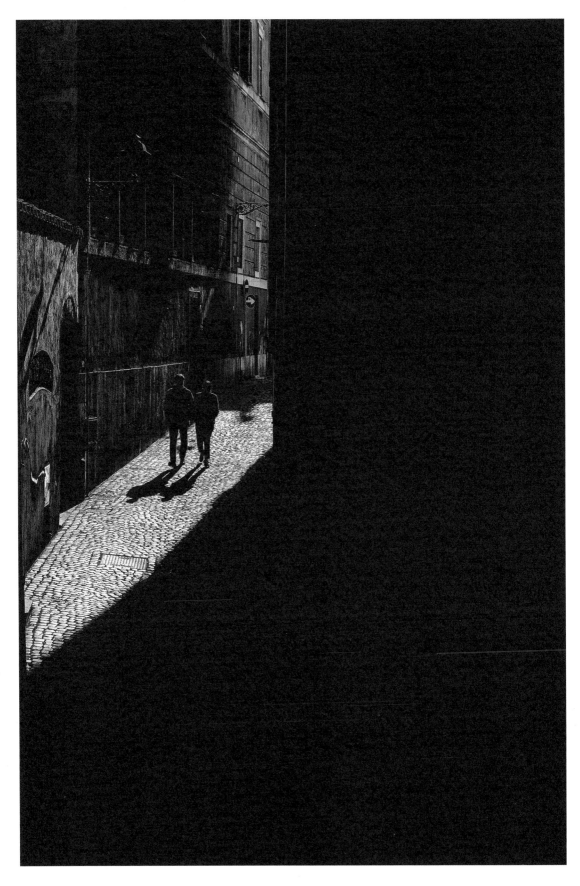

~ thank you for being there when no one else was

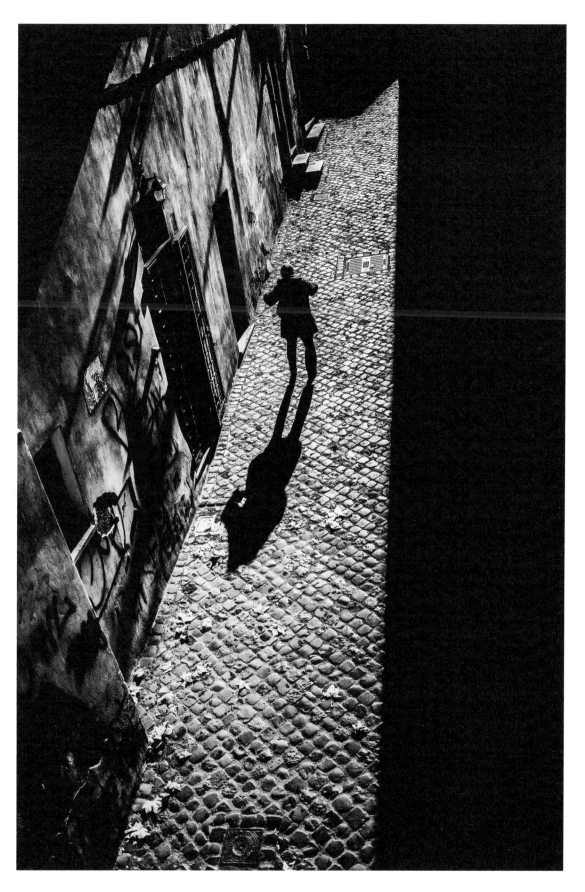

~ just watch me, I don't even need to say goodbye

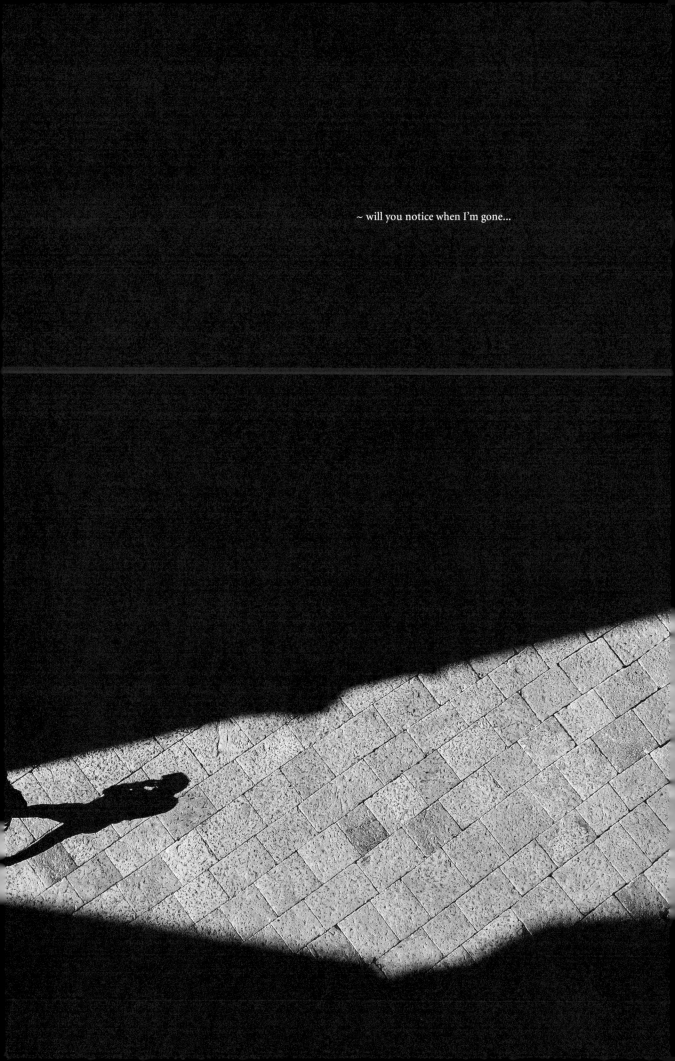

~ will you notice when I'm gone...

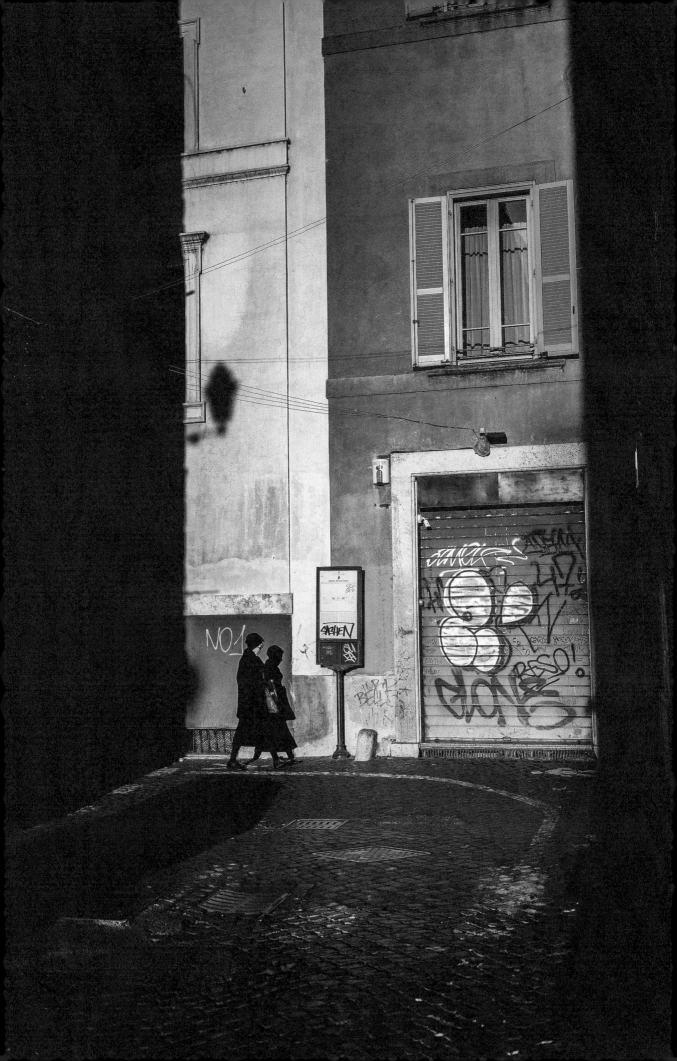

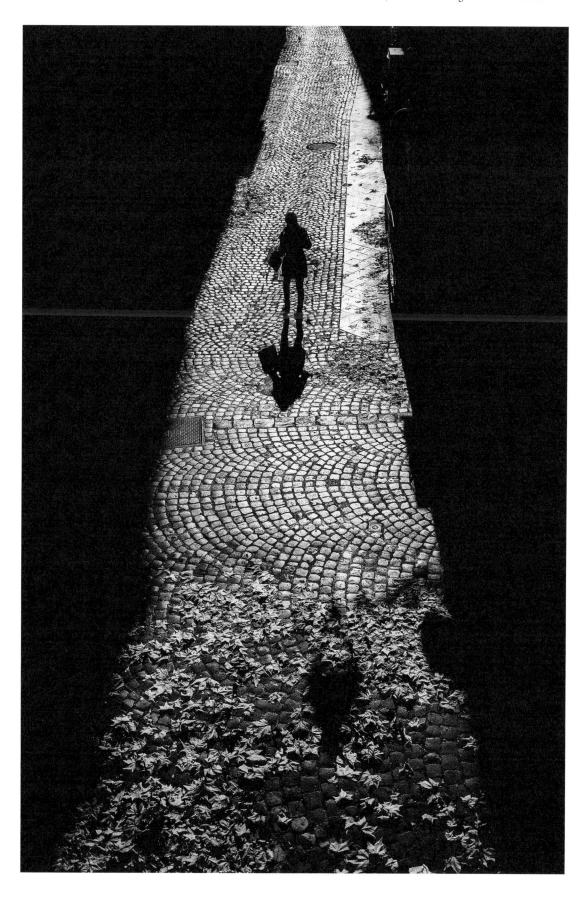

~ you just don't get it; maybe you never will; maybe I shouldn't expect you to. I'll walk away, just like I always do; but I'll keep checking, like something will be there, like you'll come back. I wish you understood

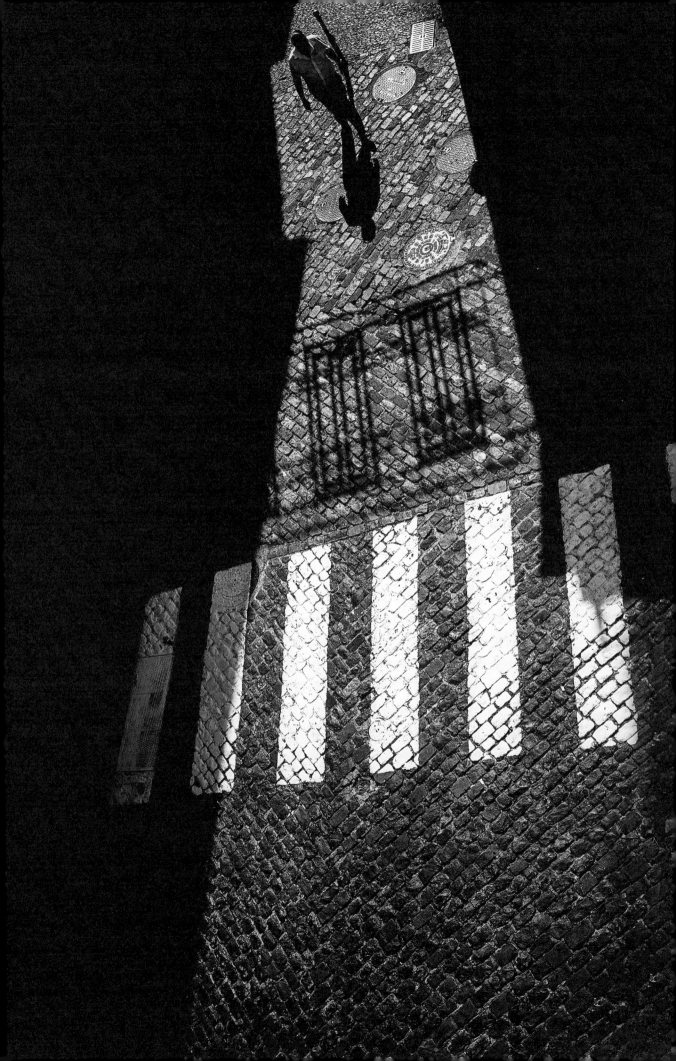

Stolen Moments

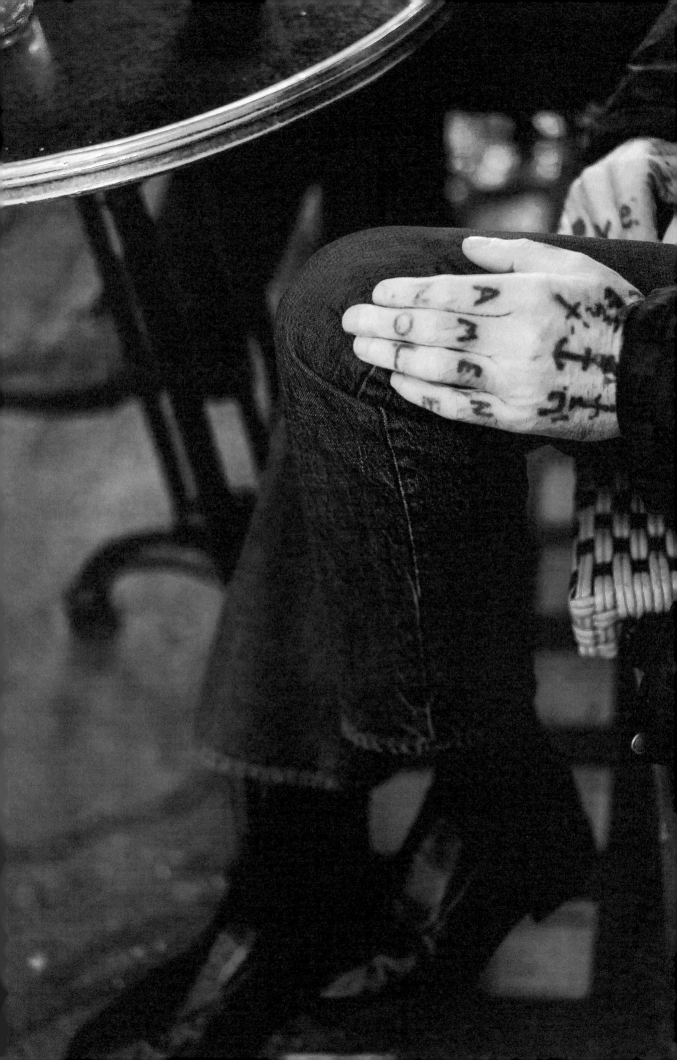

No two of us see the world the same. It's that what makes us all so beautifully unique and different. What I see and feel will not be the same as what someone else does, and I love that.

If you stop and think about it, we walk around and see people living their lives every single day – even if you are sat at home on the sofa gazing out of the window at people walking past outside, or sat on a bus, or at a bus stop, or commuting. I love that you don't know what they are going through, where they are going, what they are feeling, and what they are thinking. The street is where we live our most public life and where we all play so many roles: local, stranger, tourist, friend, enemy, commuter, colleague, parent, sibling…

We can look into the eyes of a stranger and see something much deeper than the words we might use to describe them. As you stop to look at a photo and wonder what's going on and why, think of it being like a three-way street where photographer, subject and viewer all meet.

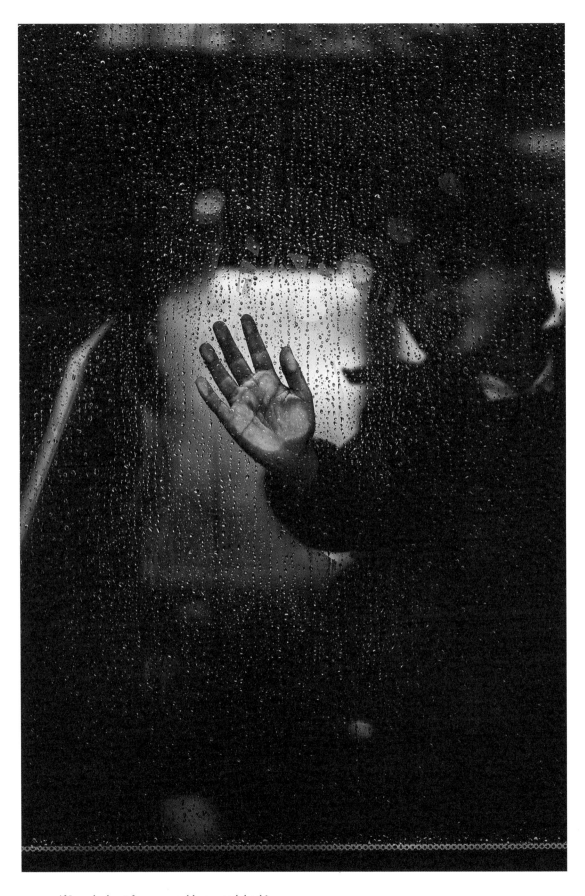

~ if I reached out for you, would you reach back?

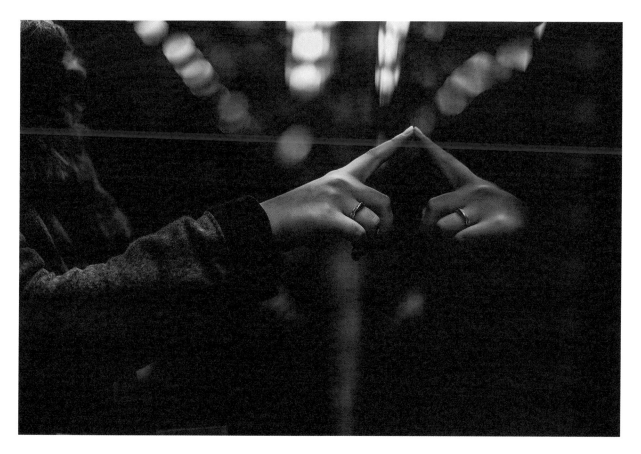

~ there are many stories happening every second of every minute, & you have a story of your own.
In my story, you play a lead role

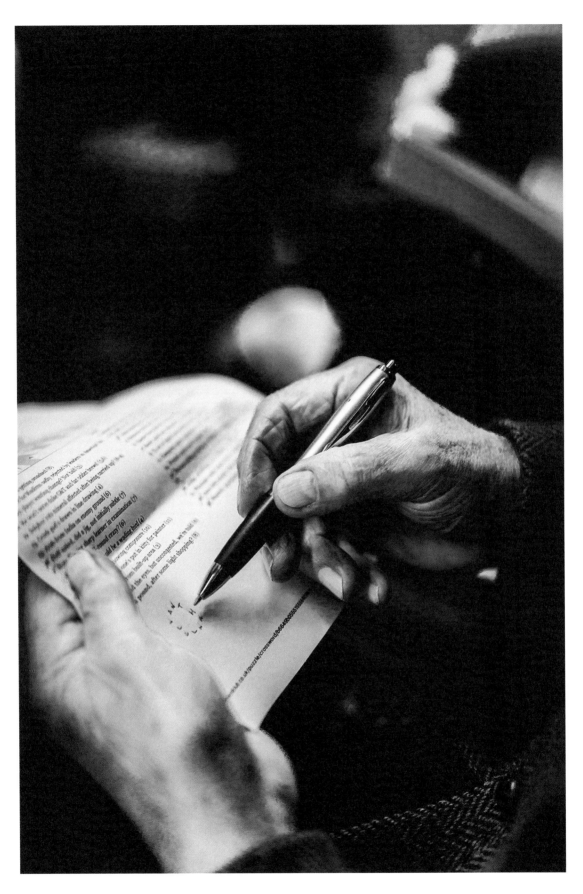

~ you were always too good for me. I'm way too practical & far too sober without you.
You were like a lovely poison I still kept coming back to. But, I'm far too functional, living
a life of routine that makes far too much sense

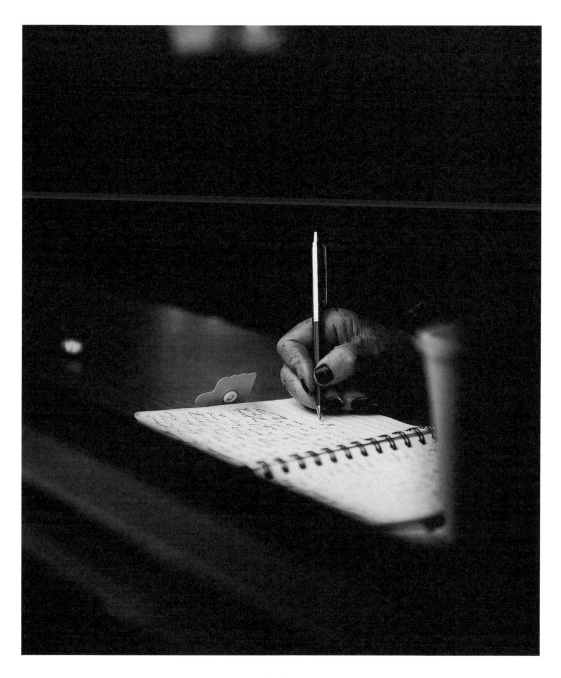

~ over & over I try so hard to write a poem about you. And every single time
I leave it unfinished; because I get so overwhelmed with emotion

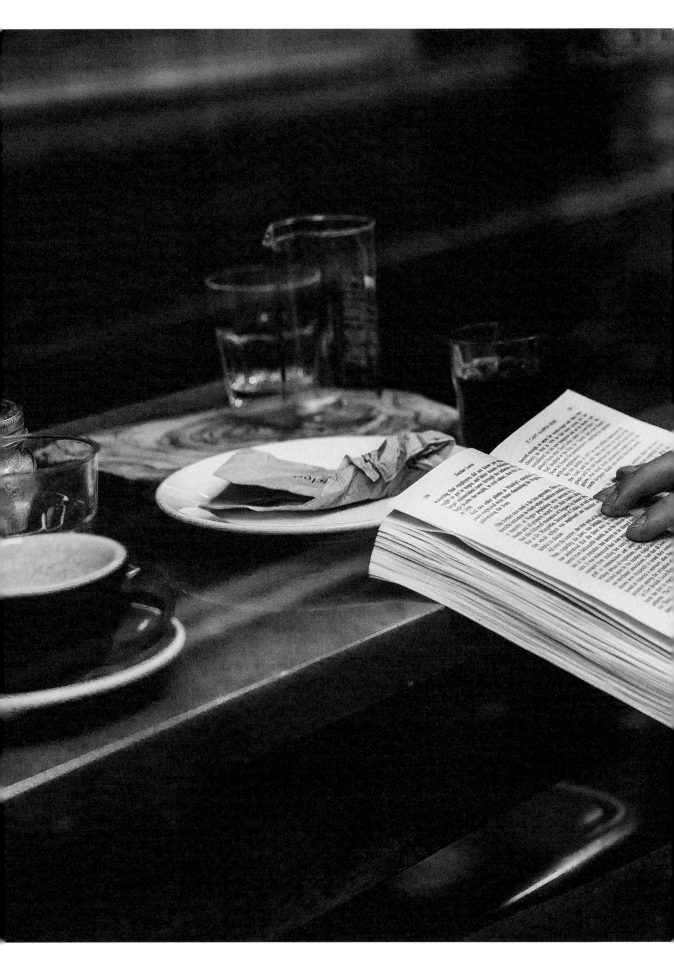

~ the hum of voices in the coffee shop is actually pretty comforting – even though I don't know the stories playing out around me; or how the voices sound when they're angry; there's an intimacy with the sound of my ears that makes me feel at home

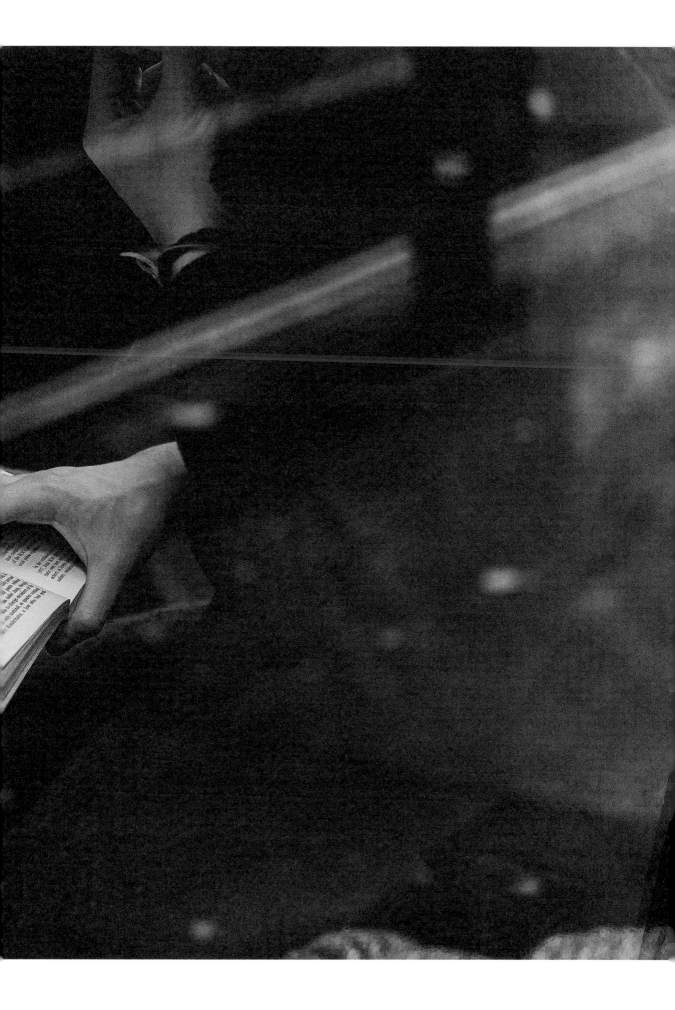

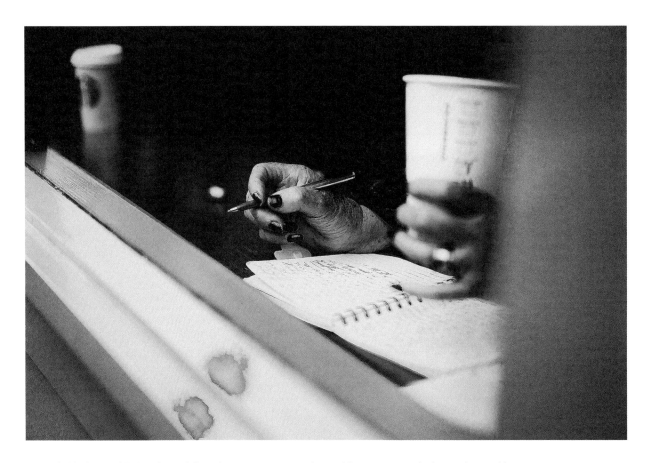

~ half of me is filled with words bursting to get out, sometimes with so many words that I trip myself
up & end up talking nonsense, & half of me is painfully shy & introverted & I never say what I really
want to say. I crave solitude & time alone, yet I also crave people, laughter, love & friendship. I want
to pour life & love into everything, yet also nurture myself & go gently. I want to live within the rush
of intuitive & spontaneous decisions & yet also wish to sit & contemplate...

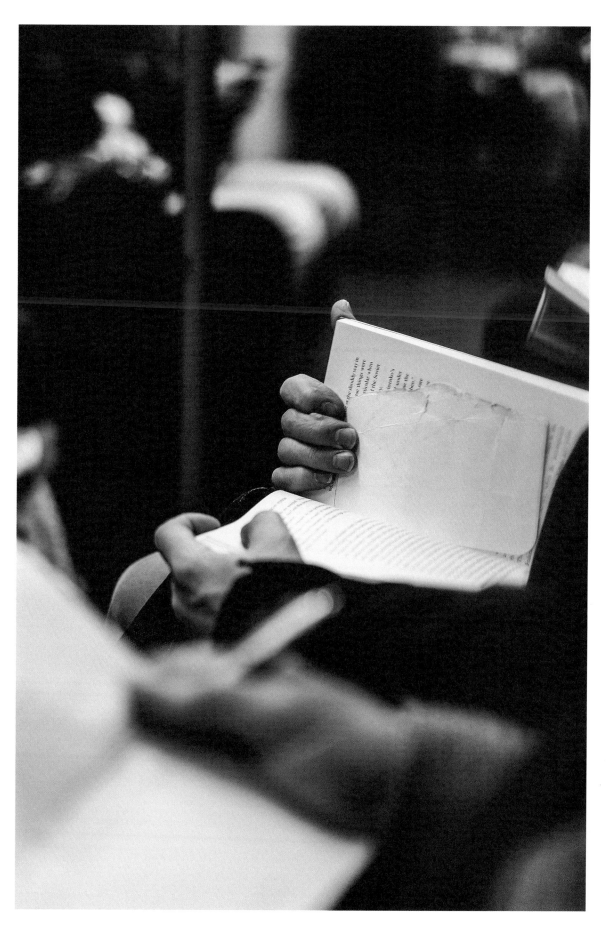

~ he wasn't always quiet; he just preferred to hide his voice carefully in forgotten notebooks &
scraps of paper; & then he left them for people willing to listen

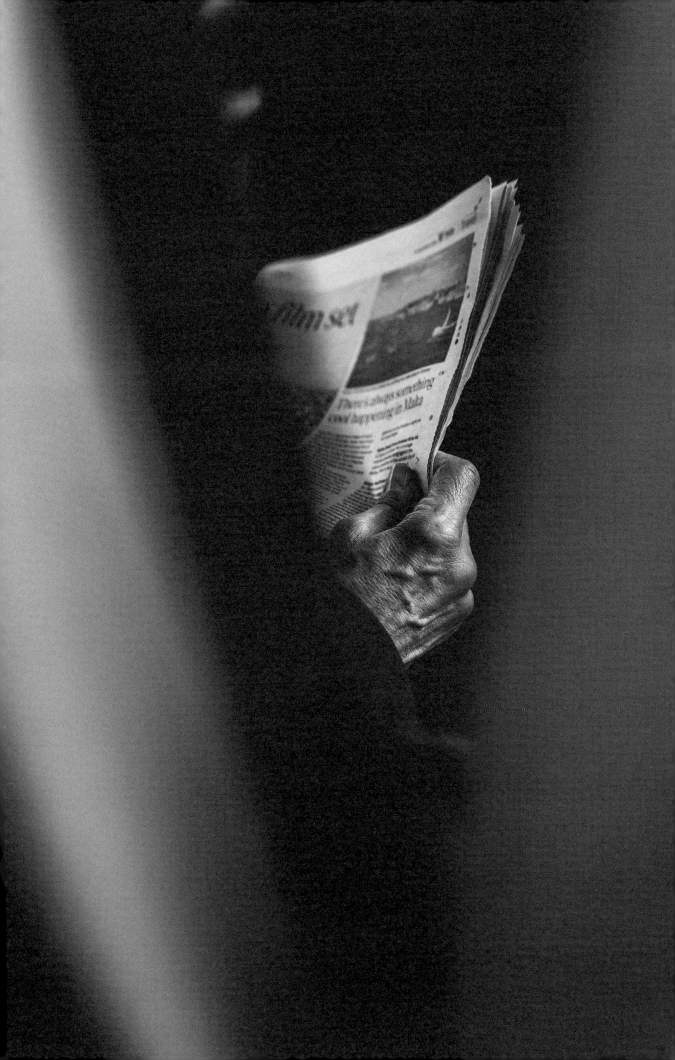

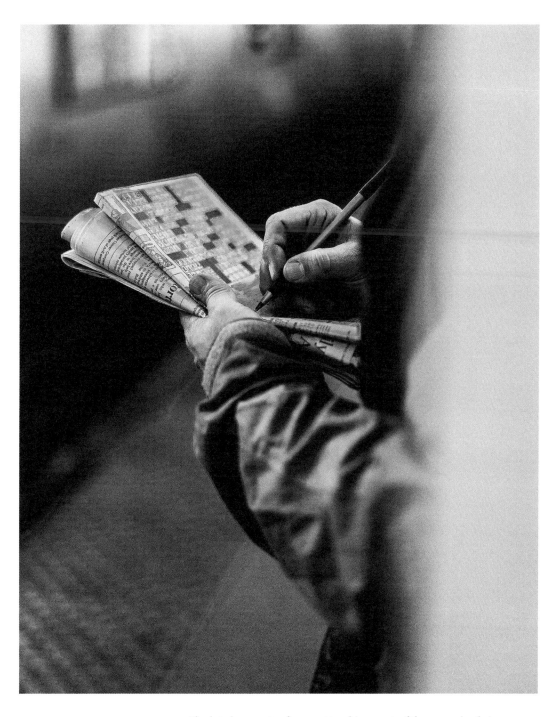

~ it's ok to have parts of you scattered in an out-of-focus puzzle of pieces

~ what we shared was never really 'ours';
 it was never really 'yours'; it was always mine

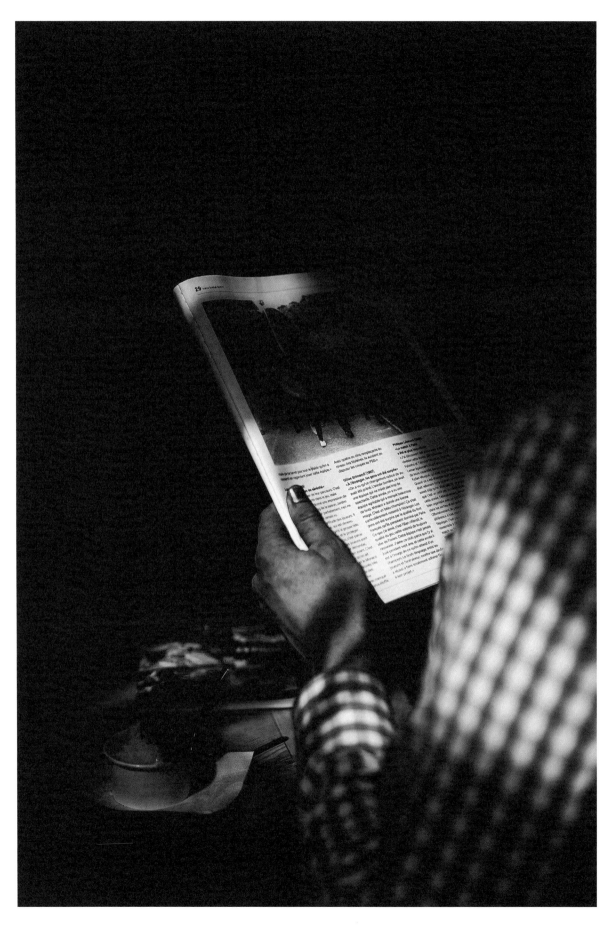

~ a quivering hand turns each page. The words become you & you become them. Their emotions are yours & you are lost, held captive in a world that isn't yours. This was his escape

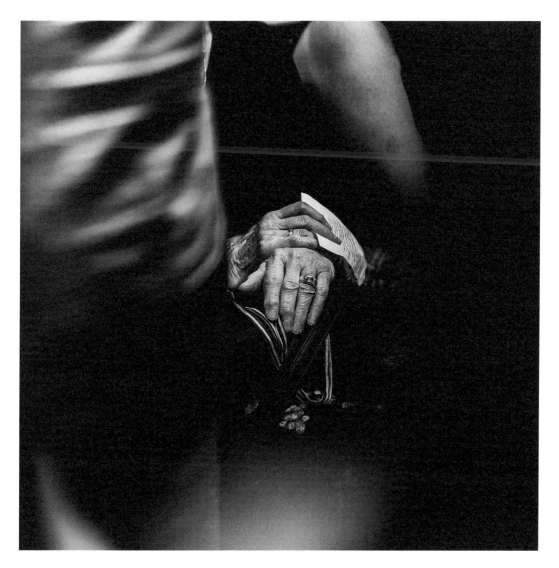

~ remember the time; it was a hot summer day & you held my hand because I was cold; the time
you comforted me while I sobbed, that was the first time you'd seen me cry; our first dance, you
complimented my new dress & hugged me after; a week later cried of happiness; remember the
time you teased me for forgetting the food shopping, we had beans on toast for dinner, it became
your favourite. Do you remember? Because it's all I'm doing these days, remembering you

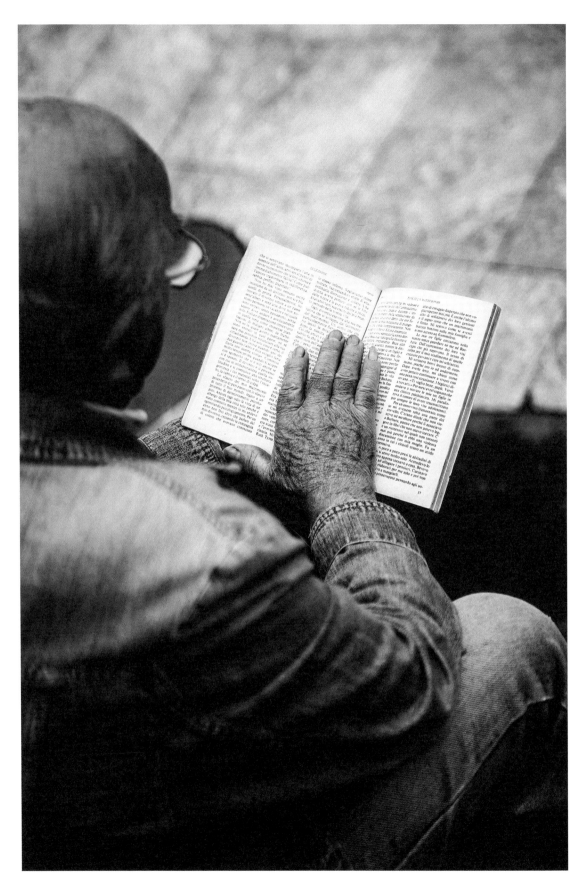

~ dear stranger; I could feel the past whispering softly into your ear; creeping into every part of you; overflowing your heart & mind, like a map with a million pinholes; covered with the people & places you loved. And, the things you continue to see & feel, you continually long for

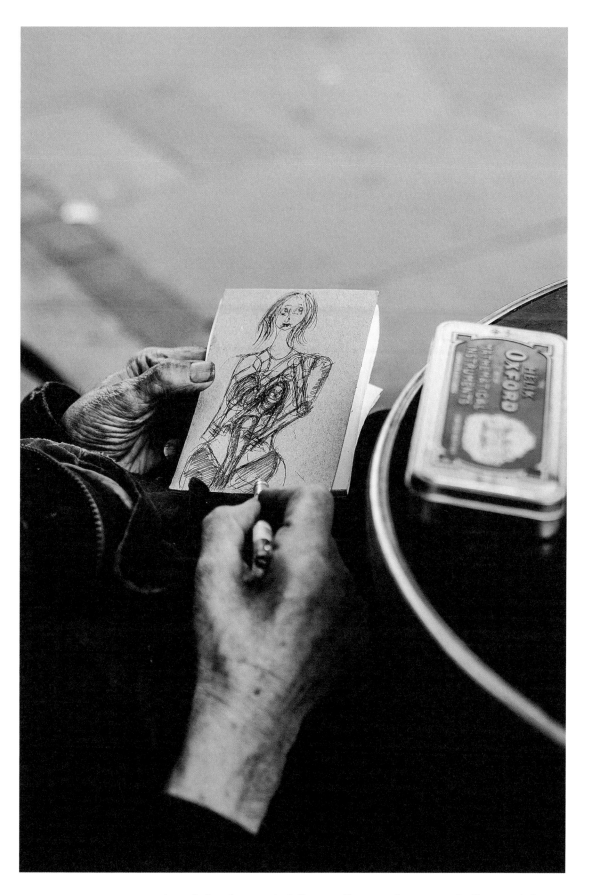

~ everyday, only for a few seconds, I allow myself to remember your touch; allow my mind
to remember your voice; but I will never allow my heart to remember your love

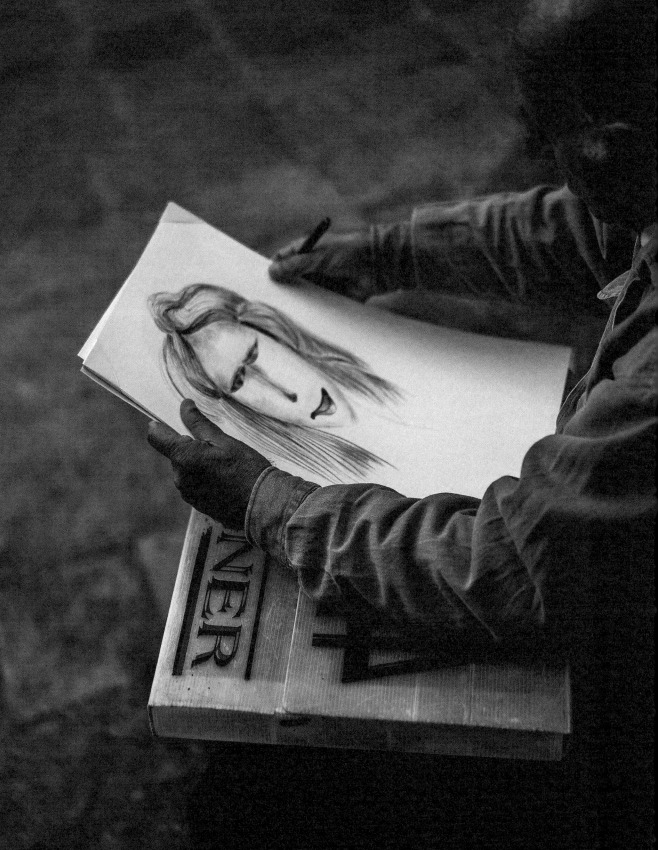

~ love & cities are intimately entwined; there's no street or hidden alleyway
in any city that doesn't double up as a place for lost love

Unfinished Stories

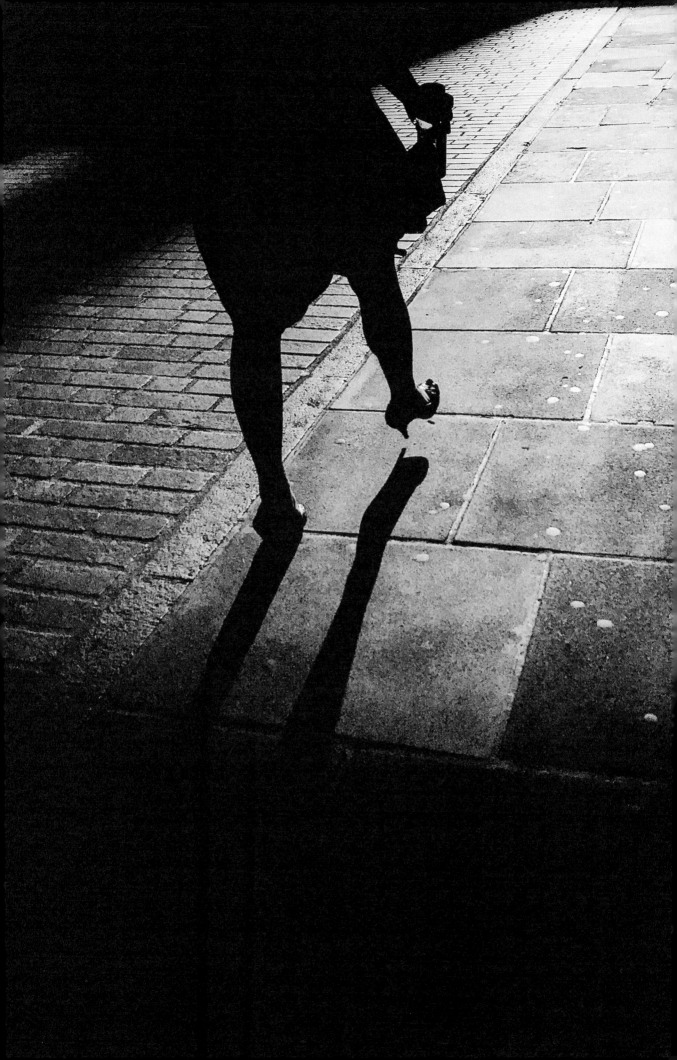

END NOTES

I often wonder, 'what if all we have ever really wanted isn't hiding in some secret and faraway dream; but it's in us now as we go about our daily lives, eating, drinking, breathing, falling in and out of love?'...

This book is a little bit like a map of my wandering feet: miniature moments, stolen seconds and blink-and-you'll-miss-them glances that have all snuck into my life. I like to think of them as 'memory keepers'. And, I want these memories, frozen time traps and stolen moments to last forever. There will always be a moment to freeze and hold onto, and I will never stop chasing them.

I know with all my heart that these photos and words are a little like a compass that led me here, and I hope they will lead you somewhere beautiful too.

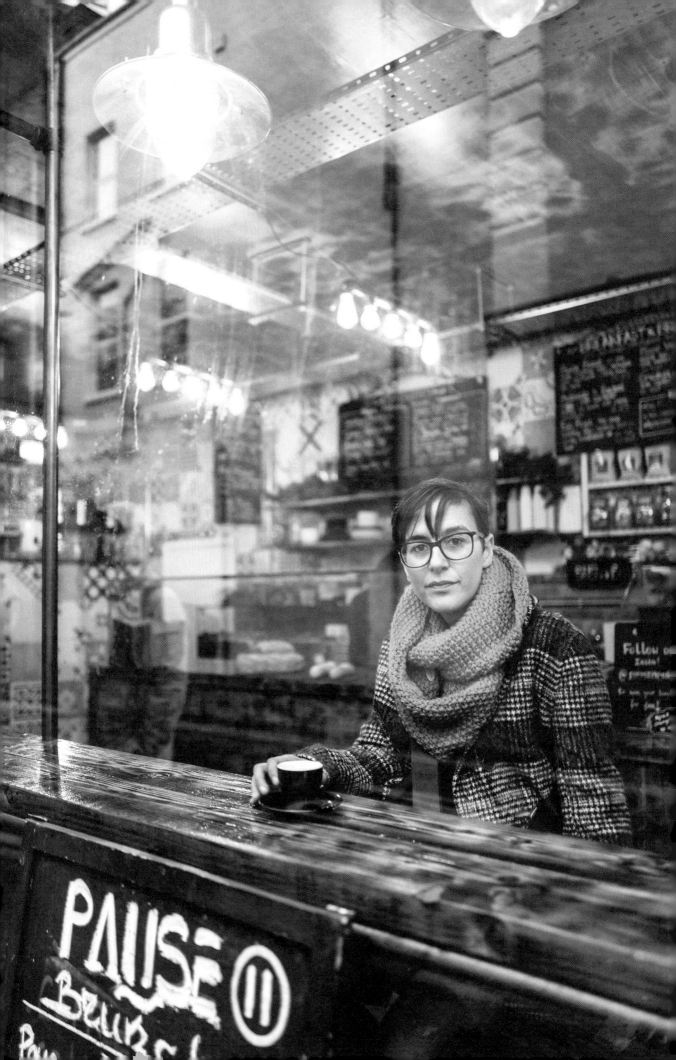

LUCY HAMIDZADEH

My passion is for travel and documenting the people and places I come across with my camera. People are a personal favourite, as they allow me to really get to know the heart and culture of the places I visit.

I draw inspiration from the people I meet and places I visit.

I love to travel – stems from a background of working in travel. I've travelled a lot through Europe and hope to do more through Asia and Africa.

I spend my days walking, shooting daily if I can, reading and writing. I love listening to music and drinking tea and coffee. There's nothing better than a day spent shooting, followed by visiting a cosy coffee shop with a notebook and pen or a book.

I loved writing as a 'secret hobby' when I was younger. I always kept a diary and would sit and scribble notes and make up stories. We always had a camera in the house, mainly for family photos and holidays and birthdays.

I love black and white movies. I believe in love and the power of it.

I love people, but also my own company, being alone to sit and think and take in the silence around me.

I believe we may not know what we want. And that we may remain a mystery to ourselves and others, but that sooner or later we discover who we've always known we are.

I love the freedom of photography, especially street photography.

I plan to continue exploring and capturing stories and moments that go unseen for years to come.

London is my hometown and somewhere I'll always have special attachment for. I love chilly crisp blue skies and sunny days, but have a deep love for shooting on rainy moody days and writing in steamy windowed cafés hugging a mug of coffee or tea. @juicylucyham

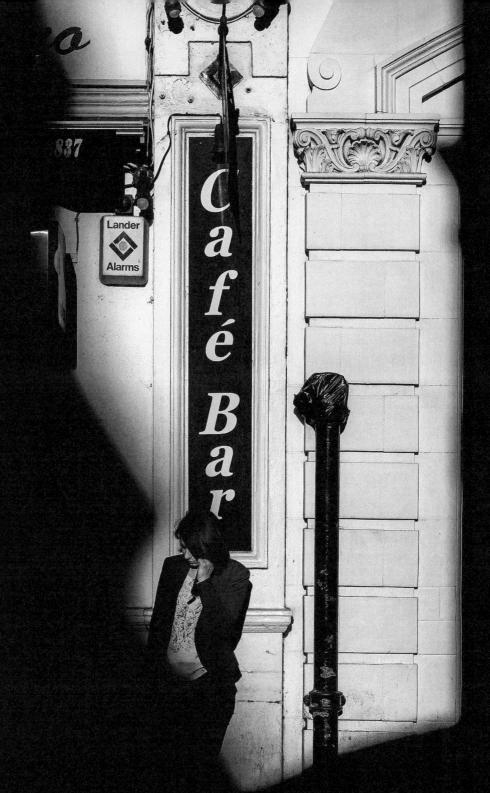

ACKNOWLEDGEMENTS

To my mum and dad – thank you for your unconditional love, care and support. For being there through EVERYTHING. I know, I don't always make it easy for you, but I hope I make you proud. And to my brother, James. I don't know how you know me better than I know myself, but you do, and I love you for that. Nothing ever feels too big or as scary as it once did because of you, and in turn, every win is done for you. You, bro, are the absolute best. Without the three of you and without all of your love, cheeky humour and kindness, I'd not be here and I'd not be me.

To the rest of my family and my close friends – old and new – I think you know who you are. A heartfelt thank you for putting up with my quirks and weird ways; for accepting me for who I am; for embracing me and my creativity; for making me giggle – a lot; for late night walks, talks and crazy spontaneous evenings out; for believing in me when I don't always believe in myself; for sticking around when others didn't and for making me a much better person. I am forever grateful to you all, and I can't wait to make so many more memories with you. You're all very special in your unique ways, and I love you all so very much.

Special thanks to Andrew, for being You and for being my friend – you've seen me at my very best and at my very worst! Being stuck up a hill in the freezing cold waving a broken shoulder at you is a memory I won't ever forget!

Thank you for being there; for being my proof-reading buddy; for listening to me whenever I have a drama, for always letting me share your taxi rides home and for being my partner in crime – you'll always be my number one work husband!

To that little app Instagram for reigniting a passion and opening up a whole new world. As cheesy as it sounds, I've grown so much because of those little squares. I will forever be grateful for the insanely talented, beautiful people I've met in the last few years. I'd never have had the courage to share these stories if it wasn't for you.

To the wonderful guys at Trope and Maday Productions. What an amazing journey it's been. Thank you SO much for believing in me, for trusting in me, for supporting me and for allowing me to live a dream. I am so very glad we got to make this together.

To all the strangers I've met on the street – I know you don't know me, and I don't know you, but thank you for unknowingly allowing me to share a moment with you. For letting me get lost in your life for a snapshot of a moment and for allowing me to share a story.

LCCN: 2019933634
ISBN: 978-1-7320618-7-3

Printed and bound in Latvia
First printing, 2019

Trope Publishing Co.

+ INFORMATION:
For additional information on
the Trope Edition Series, visit
www.trope.com

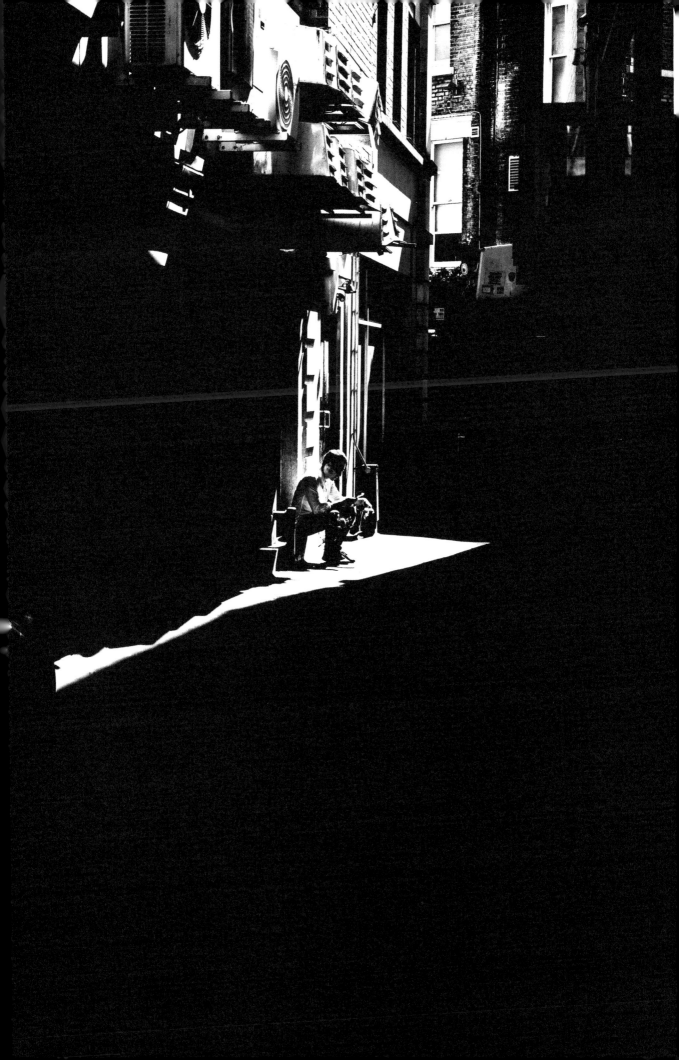

TROPE

TROPE EDITION

VOLUME I